NASCAR®

DARLINGTON RACEWAY

TOO TOUGH TO TAME

DARLINGTON RACEWAY

TOO TOUGH TO TAME

CATHY ELLIOTT
FOREWORD BY TERRY M. JOSEY

ARCADIA
PUBLISHING

Published by Arcadia Publishing
Charleston, South Carolina

Printed in the United States of America

Library of Congress Control Number: 2012949183

For all general information, please contact Arcadia Publishing:
Telephone 843-853-2070
Fax 843-853-0044
E-mail sales@arcadiapublishing.com
For customer service and orders:
Toll-Free 1-888-313-2665

Visit us on the Internet at www.arcadiapublishing.com

*For Darlington Raceway, a great lady who changed
my life by making a believer out of me.*

CONTENTS

FOREWORD

Every young boy remembers that one special girl, that first love. The one that stole his heart and forever left a mark on his soul. It cannot be explained, but every man understands what I am saying. For me, that special "she" is an unusual lady—a "Lady in Black"—a piece of asphalt lying in the coastal plain of rural South Carolina.

As a child in the early 1970s, I sat in my bedroom, a mere two miles from Darlington Raceway, trying to guess who was turning laps on that famous piece of special asphalt. Was it David Pearson? Maybe it was Cale Yarborough, or maybe it was the king himself, Richard Petty. I never really knew, but the imagination of a six-year-old created his own race, right there in that bedroom. It was the beginning of a 40-year love affair that to this day still burns brightly.

Just days before my sixth birthday, my dad, Terry, took me to my first Southern 500. This mysterious lady had also placed him under her spell, many years earlier.

My mom, Zena, made a bag of sandwiches for us. What a thrill: no more imagination. The sounds, the smells, and the roar of the engines were incredible. This was the real deal. I was really there at "The Lady in Black." There was Pearson, and there was Cale, and yes, even King Richard was on the race track. From that moment, I was in love.

That day began a decades-long tradition that ended, ironically, when I went to work at Darlington Raceway in 1990. My dad continued to make his annual visits to the track, while I worked.

I still find myself in awe of this incredible first love. I share my daily life with her. She has changed over the years. She has added new asphalt, new grandstands, and new amenities, but her spell is still as captivating today as it was for that six-year-old boy all those years ago. I cannot "imagine" working anywhere else in this big world.

My dad passed away in 2002. My son, Stephen, now makes his annual visit to the "The Lady in Black." The cycle is complete. That is Darlington.

—Terry M. Josey
Vice president and general manager of Darlington Raceway

ACKNOWLEDGMENTS

This project began with one goal: to present Darlington Raceway as I have come to know her. Darlington Raceway is one of the most historical and vital links in the NASCAR chain, but she is more than just a race track that comes alive once a year. Darlington is an integral member of her community, part of its very identity. Everyone in town has at least one story about the track. Most of them have literally grown up in her shadow. Darlington is family.

I went to the community members for help, and they responded, offering bits and pieces of history from their personal collections and, as a bonus, sharing lots of stories about their beloved "Lady in Black."

First and foremost, I would like to thank the staff of Darlington Raceway, particularly Chris Browning, Mac Josey, Dennis Worden, Sarah Hill, and Lee Taylor. They not only supported the project in spirit, but also opened their closets, their filing cabinets, and their sometimes-dusty cardboard boxes to me, even letting me snatch photographs off the wall—and climb one special wall—when the need arose.

Thanks also to Lisa Chalian-Rock for her stellar graphic skills; to Hunter Thomas for knowing you should never delete a photograph; and to Arcadia Publishing and Maggie Bullwinkel for trusting me with this special subject and for bearing with me throughout the process.

INTRODUCTION

Decades before Kevin Costner's supernatural baseball diamond rose from an Iowa cornfield in the movie *Field of Dreams*, the same story was played out in earnest in Darlington, South Carolina.

The Darlington Raceway deal was originally struck over a Saturday night card game in the town's textile mill. Local legend says that when real estate developer Harold Brasington suggested to his friend Sherman Ramsey during a friendly game of poker that they build a race track on a largely unused piece of land just outside of the city limits, Ramsey, who owned the land, replied, "Sure. Now deal the cards."

Almost one year to the day later, Darlington Raceway was open for business, hosting the inaugural Southern 500 on September 6, 1950. The day would go down in history as the beginning of a new era in motorsports, paving the way for today's high-speed chases and white-knuckle action.

Upon completion, the track itself looked a bit different than Brasington had originally envisioned it. Ramsey, an avid sportsman who loved to fish, would not allow his friend to disturb a small minnow pond located on the property, just outside of the area where the track was to be built. To save the pond, Brasington had to tighten the turns at the west end of the raceway, pinching it in on one corner and giving Darlington her trademark "egg" shape.

Darlington Raceway possesses that indefinable quality that is recognizable but difficult to describe. Some call it the "it factor," but in this case, that term definitely does not apply. Prior to 1950, no one had ever seen anything like this oddly shaped speedway before. She was a complete mystery, and in the years since, no driver has ever been completely successful in figuring her out.

The track is so deeply ingrained not only in the business of stock car racing but also in its very heart and soul that Darlington Raceway is the only speedway always referred to as "she" rather than "it."

This is a place where history has been made time and again, a place where men have become legends. It is almost easier to imagine Christmas without Santa than to picture NASCAR without Darlington. She has been on the receiving end of some criticism as newer, shinier, chrome-and-glass racing facilities caught the imagination of the public. But Darlington has never been one to back away from a challenge; she is home and knows there is no place like it.

She has been welcoming, but if some sassy NASCAR upstart needed to be taught a lesson in race track respect, she was more than willing to oblige. She has aged gracefully but has shown a canny knack for realizing that even the most legendary woman in racing can benefit from a little cosmetic help now and then. Darlington has character and personality: she is cool.

She is also a tough customer, from the abrasive racing surface to the concrete retaining wall. Drivers claim it is practically impossible to find the perfect setup for driving at Darlington because of the track's irregular configuration, and many a driver has brushed against the wall while making his way around the track.

In fact, popular opinion holds that if you have not earned your "Darlington stripe"—making contact with the wall, resulting in a long black mark on both the wall and the right side of

the car—you have not fully arrived in racing. Over the years, that wall has been swiped, and striped, by NASCAR's biggest names, who have colorfully and literally left their marks on Darlington Raceway.

In March 2003, Darlington Raceway wrote a new page in the record book by hosting the closest finish in NASCAR history, when Ricky Craven and Kurt Busch thundered door-to-door across the finish line. The cars were so closely locked together that Craven confessed after the race he had to look at the scoreboard to see who had won. Craven came out on top that day, by a margin of only .002 of a second, or a little less than three inches.

Ironically, Darlington was also the site of the largest margin of victory in NASCAR history. In the 1965 Southern 500, Ned Jarrett crossed the checkered flag an unheard of 14 laps ahead of the second-place finisher, Buck Baker. It was not exactly a riveting finish to watch, but it was historic nonetheless.

The 1965 race did offer fans plenty of excitement, however, in the form of an unscheduled aerial show, when South Carolina legend Cale Yarborough flew over the wall and sailed completely out of the track after a wreck with driver Sam McQuagg. The car eventually came to rest beside a light pole in the adjacent parking lot. Although safety equipment in those days consisted of little more than a seat belt, Yarborough suffered only bumps and bruises. He climbed out of the car and went back to the pits.

Darlington Raceway has been given quite a few colorful nicknames over the years. Some of the most popular are: "A NASCAR Tradition," acknowledging Darlington as the first asphalt superspeedway, which literally paved the way for stock car racing as we now know it; "The Lady in Black," which alludes to that famous first layer of black asphalt, unique at the time in stock car racing; and, of course, "Too Tough To Tame."

In 2004 and 2005, Darlington Raceway saw several momentous changes. Labor Day weekend and the legendary Southern 500 became another chapter in the track's ongoing story and was replaced by a state-of-the-art facility lighting system and a new race date: the Saturday evening of Mother's Day weekend. At a track where races have in the past been forced to end early due to darkness, all events are now run under the lights and broadcast to prime-time television audiences numbering in the tens of millions.

Due to the popularity and success of the May race weekend, the track's future was secured. The facility's skyline changed once again in 2006 with the addition of a new grandstand in turn one, named the Brasington Tower after the pioneer whose vision became NASCAR history.

From the humble dreams of one man to the fulfillment of the dreams of drivers and race fans alike, from the "perfectly imperfect" blend of racing's past, present, and future: This is Darlington Raceway.

One
THE MAN WHO BUILT THE LADY AND THE MEN WHO HELPED HER GROW

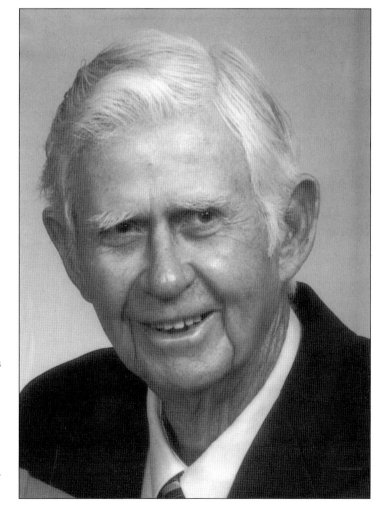

Harold Brasington, the visionary who designed and built Darlington Raceway, conceived what the townspeople referred to as his "crazy notion" to build a race track designed strictly for stock car racing after a visit to the Indianapolis 500. He believed that if Indianapolis could draw 200,000 people to watch open-wheel cars, then surely a large crowd would turn out for a stock car race in the South. (Courtesy of Darlington Raceway.)

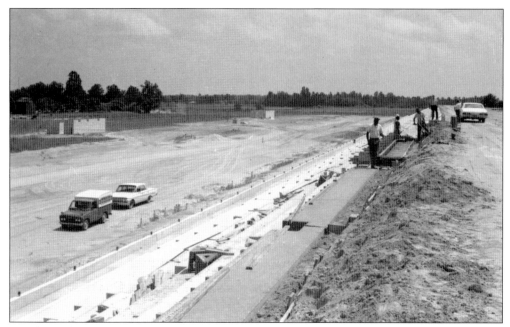

As what had once been farmland slowly began to resemble a race track, naysayers simply scratched their heads, nicknaming the facility "Harold's Folly." In the end, Brasington was vindicated, as the inaugural Southern 500, expected to attract about 5,000 fans, drew a crowd of 25,000. It was, to say the least, a spectacular success. (Courtesy of Harold Brasington III.)

Brasington, who served as Darlington Raceway's first president, also designed and built North Carolina's Rockingham Speedway, which hosted NASCAR's premier series from 1965 to 2004. He also designed several smaller tracks and a drag strip and had a fondness for arcades and bowling alleys. He conceived many big ideas at his small desk, where he also personally worked on the account books of his various projects. (Courtesy of Harold Brasington III.)

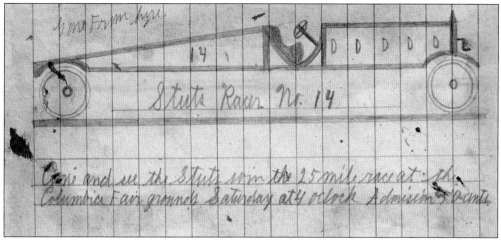

Brasington's mind was both restless and creative. He was motivated not by fame or money, but by the challenge of finding new ways to entertain ordinary people. According to his grandson Harold Brasington III, he conceived "about 100 different games, with nothing but a ball and a bucket, to keep us occupied." This "Stutz Racer No. 14" sketch is one of his early efforts. (Courtesy of Harold Brasington III.)

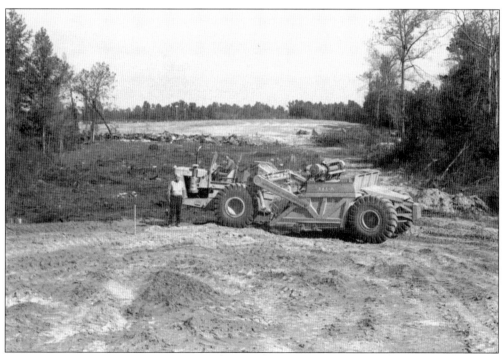

During Darlington Raceway's construction, area residents became familiar with the sight of Brasington sitting atop a bulldozer, literally building the track with his own two hands. Converting a farm into a speedway is painstaking and messy work, but eventually the project began to resemble what it would ultimately become: a groundbreaking, legendary racing facility. (Photograph by Frank Wells; courtesy of John Wells.)

Brasington did much more than conjure up the idea of Darlington Raceway. He worked tirelessly to find investors, even using the barter system to trade stock in the facility for labor and supplies. His "day job" was in the sand-and-gravel business, and as he traveled around delivering his products to various sites, he was always on the lookout for new places to build race tracks. He was also an early contemporary of NASCAR founder Bill France Sr., who had helped attract a large field for the inaugural Southern 500 by persuading NASCAR drivers to try out the brand-new track that had been constructed in Darlington. Although he was an obsessively hard worker, Brasington did occasionally take time for a rare moment of repose, although those who knew him suspect that in this photograph, he was probably reading some sort of technical journal, learning how to build something new. (Courtesy of Harold Brasington III.)

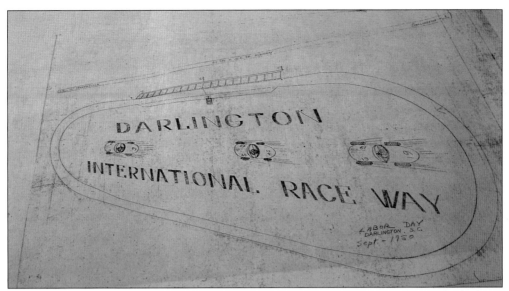

The original Darlington Raceway blueprint (above) was rather rudimentary, but it clearly shows the track's irregular shape, created when the original uniformly oval design had to be "pinched in" at one end in order to leave a small pond on the property undisturbed. Sherman Ramsey, who owned the land on which the track was built, was an avid sportsman who loved to fish. He gave Brasington permission to move forward with the project on one condition: "Don't touch my minnow pond." Below, a group of area businessmen and early investors look over the blueprint for the new speedway. Seated front and center is Bob Colvin, who would become the track's second president. (Both, courtesy of Darlington Raceway.)

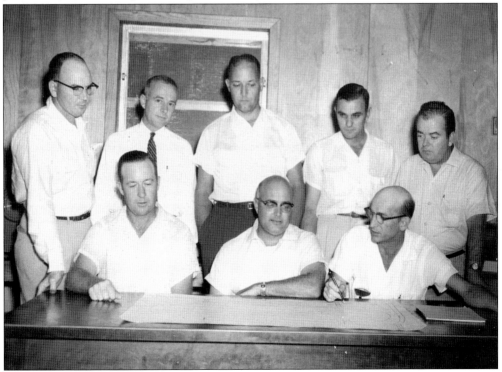

Bob Colvin (left and below) succeeded Harold Brasington as president of Darlington Raceway in 1952. Colvin, immediately recognizable because of his bald head and ever-present cigar, is remembered as one of early stock car racing's grandest and most dynamic promoters. His backslapping brand of bonhomie persuaded newspapers and radio stations that previously had not shown much interest in racing to devote precious airtime and headlines to the rapidly growing sport. Colvin was a tireless worker who not only promoted the Southern 500, but helped other venues promote their events as well. His theory was, "What helps one helps everybody." Colvin died of a heart attack at his desk in 1967, at the age of 46. (Both, courtesy of Darlington Raceway.)

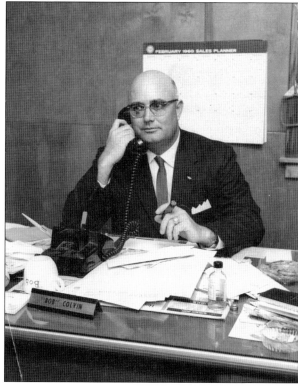

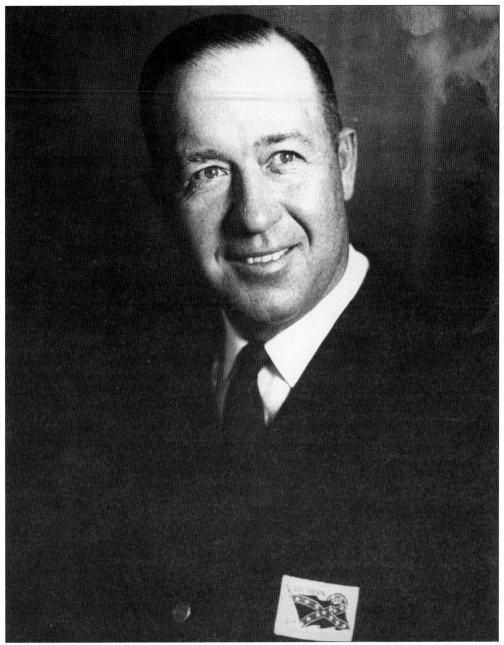

Barney Wallace assumed the title of Darlington Raceway president in 1967. Wallace, a grocery store owner, was one of the original 12 investors who each put up $5,000 to literally get Darlington Raceway off the ground, despite his banker's best efforts to convince him the track was an unwise business venture. The track was sold to International Speedway Corporation (ISC) in 1982, during Wallace's tenure, but he is best remembered as the man who first held racing events on Sunday. South Carolina's blue laws prohibited retail activities in the state on the Sabbath. The laws still exist in some areas, but they have been greatly relaxed over the years. (Courtesy of Darlington Raceway.)

After many years as Darlington Raceway's vice president, Walter "Red" Tyler (left), took over the title of president following Wallace's death in 1983. ISC set about the business of making capital improvements to its new acquisition, and Tyler was the man who oversaw them. These included the construction of a control tower and the installation of concrete walls—made famous by the legendary "Darlington Stripe"—and fan amenities such as new restrooms and concession stands. Tyler passed away in 1994, just days before the new frontstretch grandstand bearing his name, Tyler Tower (below), was completed. According to seven-time NASCAR champion Dale Earnhardt, "Red was a heck of a man. Things won't be the same at Darlington without him." (Both, courtesy of Darlington Raceway.)

Jim Hunter (right and below) was named president of Darlington Raceway in 1993. Hunter brought years of racing experience with him to the job, having worked for the media and for NASCAR and also serving stints as the director of public relations at both Darlington Raceway and Talladega Superspeedway. While Harold Brasington was known as the man who built Darlington, Hunter was known as the man who saved her. Darlington was a bit rundown and neglected when he took the reins, a battered showgirl of a track in a growing chorus line of modern, chrome-and-glass beauties. Hunter performed the miracle of making something old not only new again, but relevant and cool. During his tenure, he doubled the track's seating capacity and "flip-flopped" the racing surface, moving the start/finish line to the opposite side, where there was more space to construct new grandstands and add additional parking areas. (Right, courtesy of Darlington Raceway; below, courtesy of Cathy Elliott.)

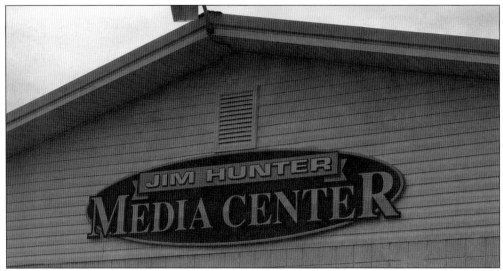

As a young newspaper reporter, Jim Hunter got hooked on stock car racing after his first experience at Darlington Raceway. Later, as the track's director of public relations, he worked closely with the media to get coverage for the "Lady in Black," garnering many headlines thanks to his outgoing, gregarious personality. As track president, he resuscitated Darlington Raceway and put her back where he always felt she belonged: at the top of the list of NASCAR's most influential facilities. Fittingly, the media center at Darlington Raceway bears his name. (Photograph by Sarah Hill; courtesy of Darlington Raceway.)

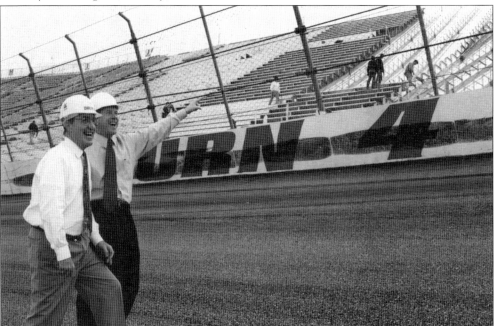

Here, Hunter and former South Carolina governor David Beasley admire the recently completed Pearson Tower grandstand, which was built during Hunter's tenure as president and added more than 12,000 new seats. According to NASCAR Hall of Fame driver and Darlington champion Cale Yarborough, "Hunter did more for this race track than everyone else put together." (Courtesy of Darlington Raceway.)

In 2001, Jim Hunter was called back to NASCAR to help with the restructuring of its media outreach and public relations efforts, so Darlington Raceway was once again in need of a president. Daytona International Speedway's vice president of sales and administration, Andrew Gurtis, seen here, was named to the position. In June 2003, it was announced that the Labor Day weekend race, run at Darlington Raceway since 1950, would move to Atlanta Motor Speedway the following year. Many felt the loss of such a historical weekend did not bode well for Darlington's future, but Gurtis's respectful treatment of the final Labor Day weekend race in 2003, and his creative promotion of Darlington's fall 2004 race, which was run in November as part of the inaugural Chase for the NASCAR Sprint Cup, drew huge crowds and kept the speedway on a forward trajectory. (Courtesy of Andrew Gurtis.)

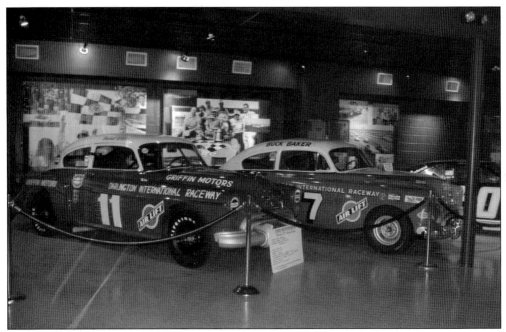

Andrew Gurtis took on the long-overdue task of updating and expanding the Darlington Raceway Stock Car Museum (above), which had not been renovated since it opened in 1965. He also oversaw the installation of Steel and Energy Foam Reduction barriers at the track, as seen below. SAFER barriers, as they are commonly known, add a protective layer of steel and foam between the race cars and the track's concrete retaining walls. Designed to absorb the impact shock that occurs when the cars make contact with the walls and to increase driver safety as a result, SAFER barriers were installed in the turns and the inside retaining wall in the spring of 2004. (Above, photograph by Cathy Elliott; below, courtesy of Darlington Raceway.)

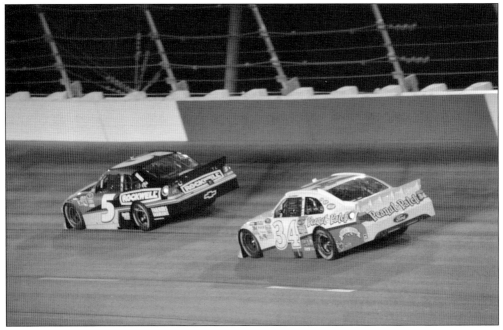

When Gurtis was reassigned to ISC corporate duties, Chris Browning was named as his replacement, becoming Darlington Raceway's seventh track president in the summer of 2004. Browning (right) brought an extensive racing resume to Darlington, including jobs as a show car driver for RJ Reynolds Tobacco Company, as assistant director of public relations and marketing at Martinsville Speedway, and as director of public relations for Penske Speedways. He eventually returned to his native North Carolina to serve as the account executive for Maxwell House Coffee's racing program, with popular driver Sterling Marlin. He began working at Rockingham Speedway (formerly North Carolina Speedway) in 1992. Browning has manned the helm during many facility improvements at the "Lady in Black," including the construction of the new Brasington Grandstand in turn one, resurfacing of the track, and construction of a new infield access tunnel (below). (Right, courtesy of Darlington Raceway; below, photograph by Cathy Elliott.)

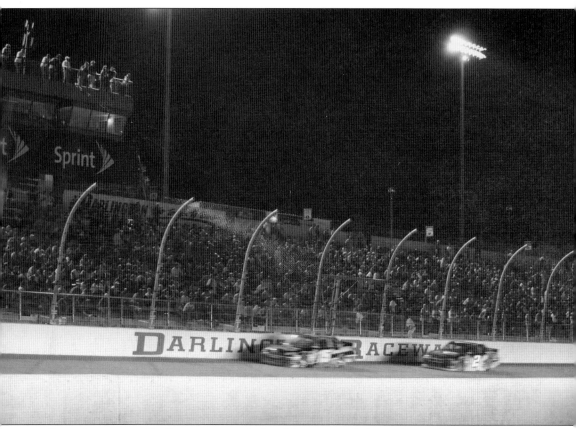

Browning came to Darlington at a critical and busy time. As he took over the president's chair and settled in, the track was in a state of flux. Realignment had moved the traditional Southern 500 weekend from Labor Day to November. A new "playoff" system had created the Chase for the NASCAR Sprint Cup, and no one was quite sure how popular it would be or even exactly what it was. The Chase encompassed the season's final 10 races, and Darlington was ninth on the list. November weather in the Carolinas can be iffy, but Mother Nature, who is apparently a Darlington fan, ultimately cooperated and the fans turned out in droves to see an up-and-coming driver named Jimmie Johnson win the race. It was the first event at Darlington to end at night, thanks to the track's newly installed lighting system, seen here. As of 2005, all events at Darlington Raceway were scheduled to be run under the lights. (Photograph by Hunter Thomas.)

Two

THE CHANGING FACE OF A NASCAR TRADITION

In 1950, grandstand seating at Darlington Raceway was a rudimentary affair. As the demand for more seats increased with each passing season, requests for more comfortable ones did too. Over time, these original bleacher-style seats, which were mainly slabs of concrete, were replaced by new, individually numbered seats complete with back support, so attendees can watch the races in comfort. (Courtesy of Darlington Raceway.)

Darlington Raceway often invites comparisons to the popular 1989 film *Field of Dreams*. Like the lead character in the movie, most of the local population thought visionary land developer Harold Brasington had "gone soft in the head" when he began carving a race track out of farmland just outside the city limits. The site became an attraction of sorts, as the locals would sometimes pack a picnic lunch on weekends and go out to watch the work in progress. The more open-minded among them found themselves in danger of having their leisurely Saturday afternoons interrupted, however, as Brasington would often recruit them to get up and help with the work. In this photograph of the early stages of construction, an abandoned barn still sits beside the partially completed speedway, waiting to be torn down. (Courtesy of Darlington Raceway.)

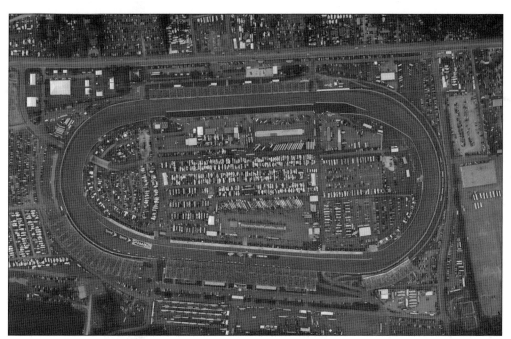

These aerial race day photographs, taken from both a small plane flying over the track and from the upper reaches of Darlington's newest seating option, the Brasington Grandstand in turn one, both showcase a thoroughly modern facility that has weathered NASCAR's many changes. Originally designed to seat about 7,000 fans in the grandstands, Darlington can now comfortably accommodate almost 10 times that number. Parking is plentiful and concession stands and other food and beverage vendors offer an array of tempting options. As the facility's physical amenities have evolved around her, the action at Darlington has, for the most part, remained consistent. Speeds are faster and the equipment is more sophisticated, but the racing is as unpredictable as it was in 1950, perennially keeping the track on the list of NASCAR's most popular destinations. (Both, courtesy of Darlington Raceway.)

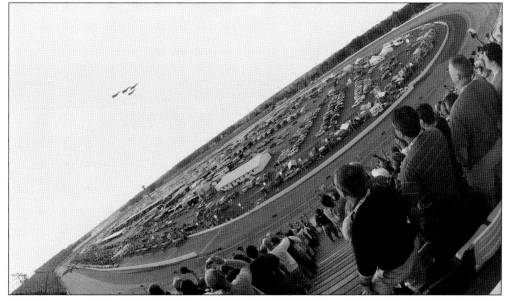

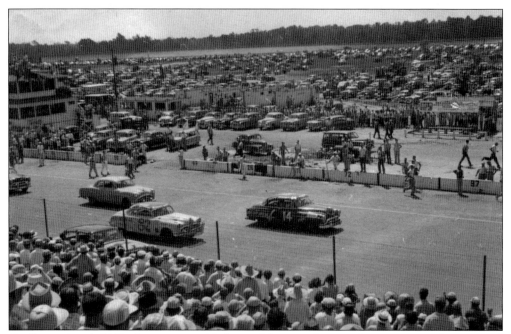

On September 4, 1950, the racing world changed forever when stock cars competed on a paved speedway for the first time in history. A field of 75 cars, lined up three wide, started the inaugural Southern 500. The following year, 82 cars started the event, making it the largest field in NASCAR history, another Darlington record. (Courtesy of Darlington Raceway.)

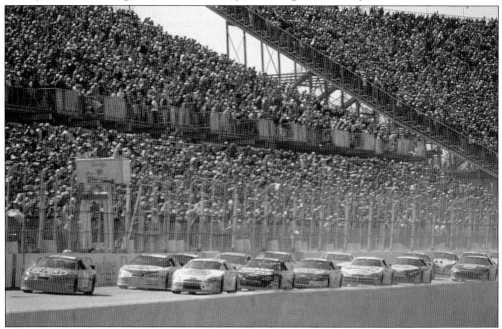

In modern times, 43 cars compete in each event in the NASCAR Sprint Cup Series. The field now consists of the 36 fastest drivers in qualifying plus the six drivers highest in owners points who have not already qualified on speed with the final spot going to the most recent eligible past champion driver. (Courtesy of Darlington Raceway.)

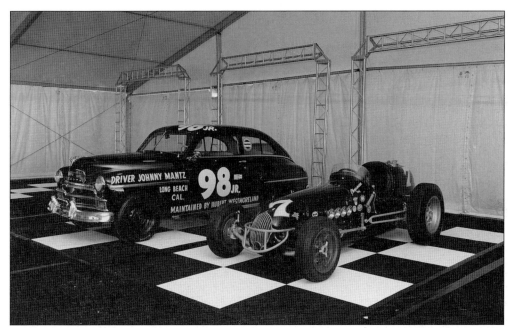

The inaugural Southern 500 was won by Johnny Mantz, the slowest qualifier for the race, who simply wore out the rest of the field by using harder tires and riding around on the apron for the entire 500 miles, going into the record books as Darlington Raceway's first-ever champion. Mantz's winning Plymouth, which resides in the Darlington Raceway Stock Car Museum, is seen here alongside "Basement Bessie," the homemade car that won the first IndyCar race at Darlington, also in 1950. (Courtesy of Darlington Raceway.)

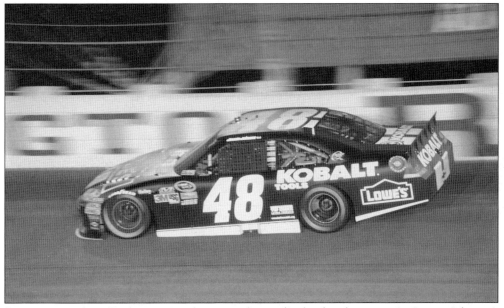

Sixty-two years later, Darlington was the setting for another landmark moment, as Jimmie Johnson's 2012 Bojangles' Southern 500 victory was the 200th win for Hendrick Motorsports. The paint scheme on Johnson's No. 48 Chevrolet continued the tradition of black cars winning significant races at Darlington. (Photograph by Hunter Thomas.)

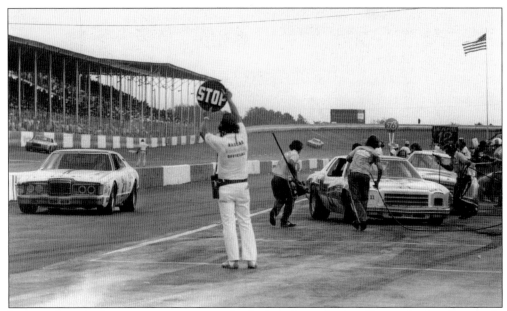

In racing's early days, pit stops were not the high-tech, professionally coached and precisely choreographed bursts of activity seen today. When a driver neared his pit area and the team wanted him to come in for tires, fuel, or other maintenance, they communicated their instructions the old-fashioned way, by means of a handheld sign. (Courtesy of Darlington Raceway.)

Technological advancements have taken much of the guesswork out of racing. Teams know, almost to the last drop of fuel, how far their driver can go before coming in for a pit stop. Pit stalls are small and very close together, so in order to give drivers adequate time to judge when and where to start braking, teams hang easily recognizable signs like these over the stalls, giving the driver no excuse to miss them. (Photograph by Hunter Thomas.)

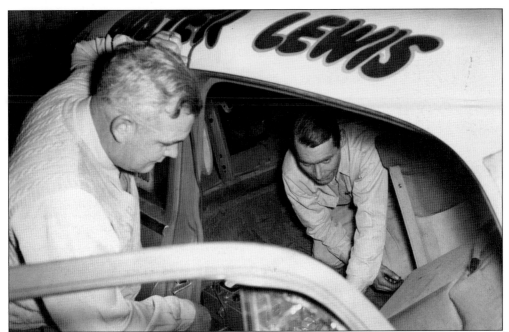

NASCAR team owner Ernest Woods (above, left) watches the installation of a General Electric two-way radio in one of his Oldsmobile stock cars, driven by Emery Lewis. According to Woods, the radio would "aid greatly in the safety of both drivers and spectators." Jim Paschal drove one of Woods's radio-equipped cars in the 1954 Southern 500 at Darlington Raceway, finishing fifth. Paschal was inducted into the National Motorsports Press Association Hall of Fame, which calls Darlington Raceway home, in 1977. No longer reliant on handheld transmitters, drivers now communicate with their teams by way of tiny earpieces and microphones, which run directly into their helmets, as seen below, allowing them to keep both hands on the wheel. (Both, courtesy of Darlington Raceway.)

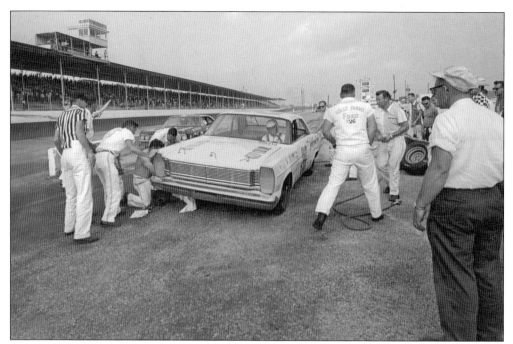

Junior Johnson won 50 races in the 1950s and 1960s before making the transition from driver to owner. Here, Johnson's team performs a pit stop on the No. 26 Ford in the 1965 Southern 500. Johnson finished dead last in the race, while Ned Jarrett cruised to the win by a margin of 14 laps. The average time for a pit stop, including changing the tires and filling the fuel tank, was 45 seconds. (Courtesy of Darlington Raceway.)

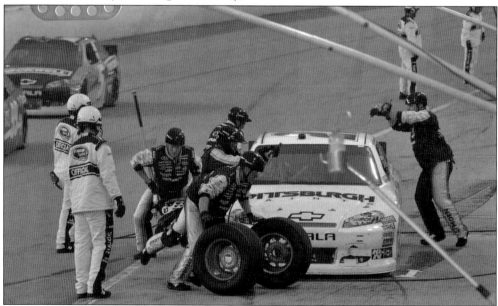

The No. 27 Menards/Pittsburgh Paints team gets driver Paul Menard back on track at Darlington in May 2012 in a timely manner. In today's NASCAR, pit stops are a choreographed exercise in precision and teams taking longer than 14 seconds to get their drivers out of the pits are taken to task for an unacceptably slow performance. (Photograph by Hunter Thomas.)

It is ironic that one of the best-loved sights during the fast, loud Darlington race weekend is a machine known for moving slowly. The famous Goodyear blimp has been making its placid way through the skies since 1925. A Goodyear blimp first flew over the Olympic Games in Los Angeles in 1932 and first carried a camera above a sporting event in the 1960 Orange Bowl. Since that popular debut, blimps have become familiar sights at NASCAR races. At right, at Darlington in the 1970s, directional signage is instructing the Goodyear blimp to go left—NASCAR's direction of choice—but the blimp apparently has other ideas. Below, in 2012, the DirectTV blimp's state-of-the-art, full-color video screen that flew over the Bojangles' Southern 500 at Darlington was so bright that the blimp itself was almost invisible. (Right, photograph by T. Taylor Warren, courtesy of Cathy Cross Kirby; below, photograph by Hunter Thomas.)

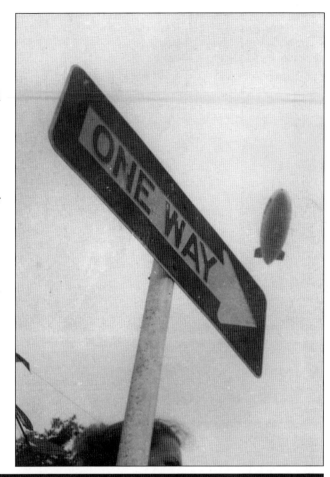

Every
NASCAR

Structures are not the only things at race tracks that undergo a change of appearance with the passage of time; the same applies to people. Richard Childress Racing (RCR) began as a single-car operation, but what a car it was. Childress (left and below) founded RCR in 1969 and competed in the NASCAR Sprint Cup Series as a driver until 1981, when he handed the wheel over to the "Man in Black," Dale Earnhardt Sr. Earnhardt ran 11 races for RCR that year but left the organization at the season's end, returning in 1984. Together, Childress and Earnhardt won six NASCAR championships in the iconic No. 3 Chevrolet. (Photograph by Terry M. Josey.)

Today, RCR has grown into a multi-car organization, fielding three cars in NASCAR's premier series in 2012, and a couple of younger Childresses have gone into the family business. Ty and Austin Dillon, Childress's grandsons, have both enjoyed NASCAR victories driving for RCR, giving their proud grandfather two more reasons to be at the track. (Courtesy of Cathy Elliott.)

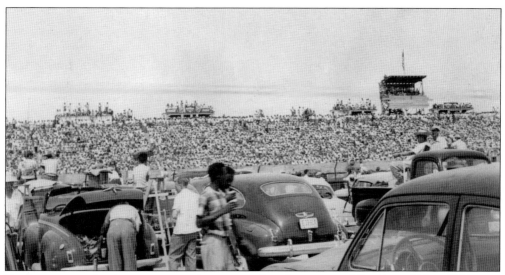

Track promoters hoping to attract a decent crowd to the inaugural Southern 500 in 1950 got a little more than they bargained for when 25,000 fans showed up. When the grandstands were full, track officials decided to allow spectators to watch the race from inside the speedway, creating an infield culture that still flourishes today. Back then, fans watched the races from wherever they could find a place to sit or stand, including the hoods of their cars or, for the little ones, on their fathers' shoulders. (Courtesy of Darlington Raceway.)

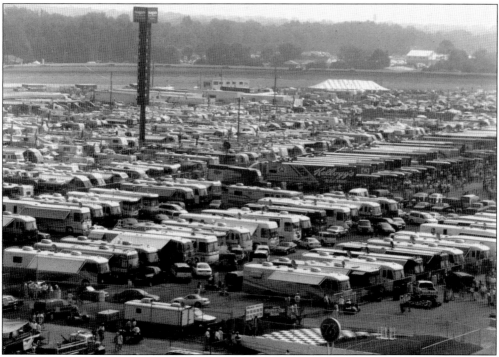

Today, the infield is crowded with motor homes, car haulers, hospitality suites, and garages, but plenty of room is still reserved for fans, many of whom spend the entire weekend inside the track. Their accommodations range from luxury RVs to tents, but they share the same reason for being there: love of the Darlington Raceway experience. (Courtesy of Darlington Raceway.)

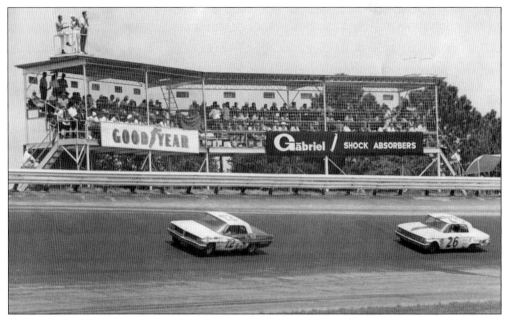

From the very first day the gates were thrown open, media members turned out in record numbers to cover the races at Darlington. In the days before the PGA and the Women's Tennis Association made regular visits to South Carolina, the track was the only professional sporting venue in the state. Members of the press, along with politicians, celebrities, and other VIPs, had the somewhat dubious privilege of watching the races behind the relative safety of chicken wire. The "chicken coop" was considered premium seating at the track. Today, Darlington Raceway entertains most of her visiting dignitaries in the suite towers located in turn three. Some suites are sold to businesses and one is designated as the press box, while others are retained by the track for the use of invited guests. (Both, courtesy of Darlington Raceway.)

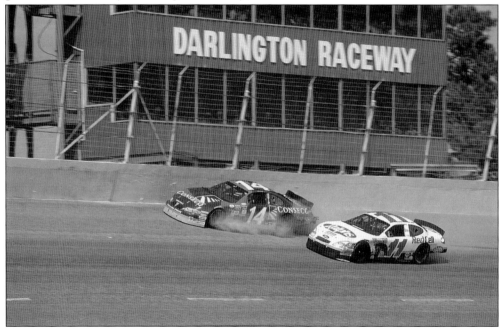

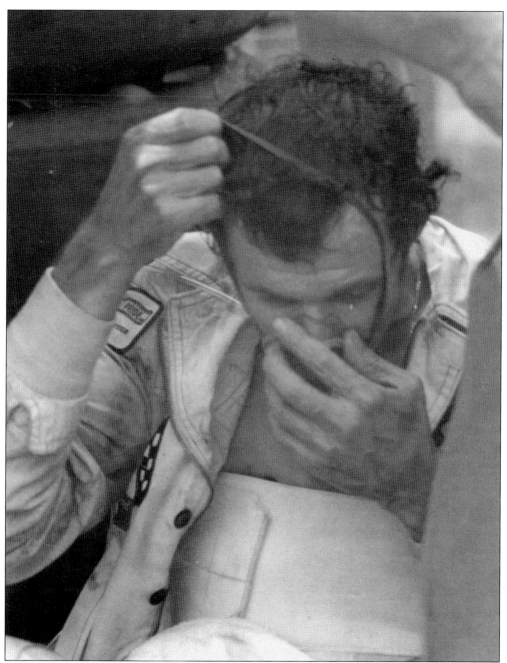

Infield care centers at modern NASCAR facilities are the equivalent of field hospitals, prepared for any emergency. Each track has its own medical director, and a full medical staff is on site for every event, including trauma surgeons, emergency medicine doctors, and neurosurgeons. Helicopters are ready at all times in case air transport is necessary. Cooling systems pump air inside the drivers' helmets during races to try to keep them comfortable in temperatures that can exceed 130 degrees inside the car. Things have come a long way since the days when Richard Petty administered the self-treatment seen here, slipping on his own oxygen mask after a wreck at Darlington in the 1970s. (Courtesy of Darlington Raceway.)

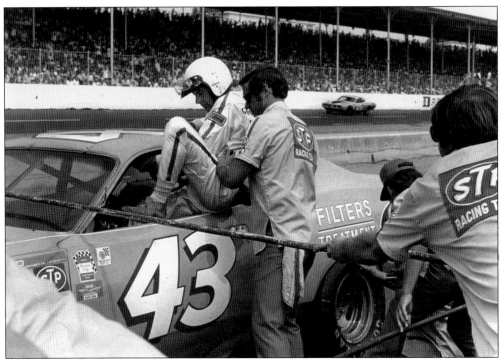

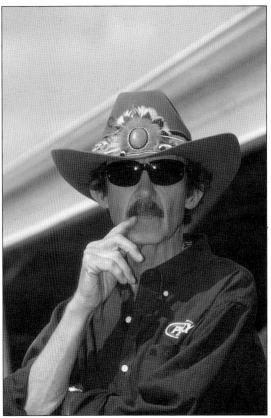

Richard Petty competed in 65 races at Darlington over the course of his legendary career. Although he did well, winning three times, Darlington was not a track he habitually dominated. Nevertheless, fans never grew tired of the sight of one of the sport's most popular drivers and NASCAR's all-time race winner climbing into his familiar blue No. 43 car (above), ready to go barreling around the track "Too Tough To Tame." Decades later, Petty, now a team owner, remains a familiar sight around the garage, sporting his famous cowboy hat and sunglasses as he intently watches his cars compete at Darlington. (Both, courtesy of Darlington Raceway.)

Three
PAGEANTS, PARADES, AND POPULAR PERSONALITIES

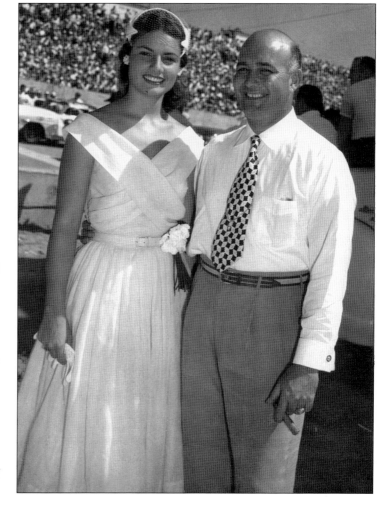

Darlington Raceway's second president, Bob Colvin, created several new events to add excitement to the race weekend, including the Southern 500 Parade and the Miss Southern 500 pageant, which was held on the track's frontstretch the evening before the race. Colvin is seen here with the first Miss Southern 500, Martha Dean Chestnut. (Courtesy of Darlington Raceway.)

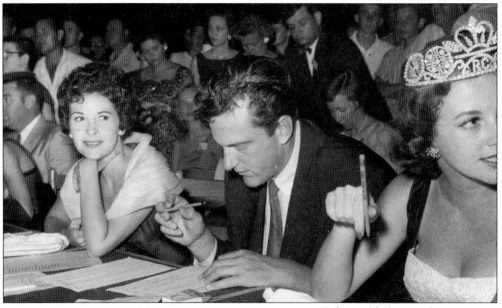

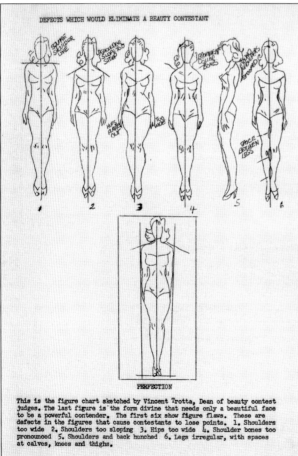

DEFECTS WHICH WOULD ELIMINATE A BEAUTY CONTESTANT

PERFECTION

This is the figure chart sketched by Vincent Trotta, Dean of beauty contest judges. The last figure is the form divine that needs only a beautiful face to be a powerful contender. The first six show figure flaws. These are defects in the figures that cause contestants to lose points. 1. Shoulders too wide 2. Shoulders too sloping 3. Hips too wide 4. Shoulder bones too pronounced 5. Shoulders and back hunched 6. Legs irregular, with spaces at calves, knees and thighs.

Colvin added some glamour to the Miss Southern 500 pageant, which he created in conjunction with the Darlington Police Department, by inviting celebrities to serve as guest judges. Generally unaccustomed to the rules of the pageant world, judges like *Gunsmoke* star James Arness (above) were given a detailed set of instructions to follow when scoring each contestant. (Photograph by T. Taylor Warren; courtesy of Cathy Cross Kirby.)

In the 1950s, physical appearance was still of the utmost importance at beauty pageants. Included in the judges' information package was this diagram explaining how to determine which contestants had the "form divine" considered necessary to represent Darlington Raceway at the state and national levels. It apparently worked, as the first Miss Southern 500, Martha Dean Chestnut, went on to win the title of Miss South Carolina. (Courtesy of Cathy Cross Kirby.)

Westerns were all the rage on television in the 1960s, and one of the most popular and enduring was *Gunsmoke*. In 1958, James Arness was invited to participate in the Southern 500 activities. The actor, who played Marshal Matt Dillon on the show, had a busy weekend. He met with the families of the Darlington Police Department, was the grand marshal of the Southern 500 parade, and served as head judge at the Miss Southern 500 pageant. Seen at right with Arness is Nita Huntley, the daughter of Sgt. Preston Huntley of the Darlington Police Department. Nita Huntley said that Arness was "the most congenial, cooperative and polite guest. His only requests were that he not be asked to kiss anybody, or ride a horse." Below, Sgts. Earnest Dutton and Preston Huntley show off the custom-painted car provided for Arness's use during his Darlington visit. (Both, courtesy of Nita Huntley.)

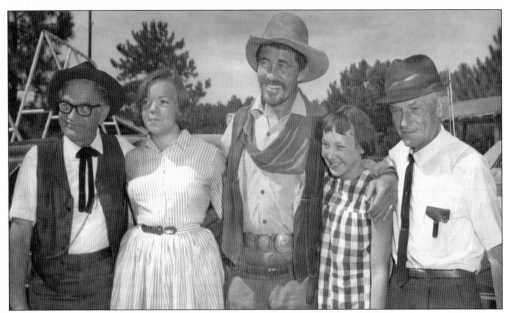

Most of the cast of *Gunsmoke* made appearances at the Southern 500 weekend over the years. Seen here at a Darlington Police Department gathering are, from left to right, Milburn Stone, who played Doc; Nita Huntley, the daughter of Sgt. Preston Huntley; Ken Curtis, who played Festus; an unidentified friend of Nita Huntley's; and Darlington police chief Peele Privette. (Courtesy of Nita Huntley.)

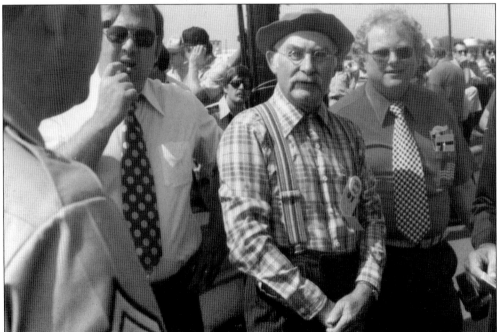

Celebrities did not have to star in Westerns to be invited to Darlington; the track also hosted Grandpa Jones (second from right), the well-known banjo player and star of the *Hee Haw* variety series known for his "Hey, Grandpa, what's for supper?" segment. In 1978, Jones rode in the lead car at the Southern 500 parade and was a judge at the Miss Southern 500 pageant. (Photograph by A. Terry Josey; courtesy of Terry M. Josey.)

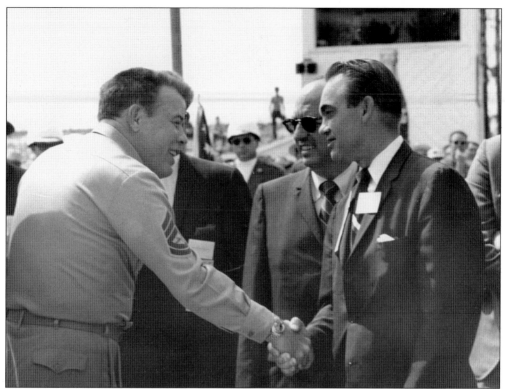

A couple of notable Carters paid visits to the "Lady in Black" in her earlier years. In 1968, Frank Sutton, who played the role of Sgt. Vince Carter on the hit television show *Gomer Pyle, U.S.M.C.*, was grand marshal for the Southern 500 parade. Sergeant Carter (above left) rarely looked happy on the show, but he was all smiles as he shook hands with another high-profile guest, presidential candidate George Wallace (above right). In 1976, Billy Carter (below), the colorful brother of Jimmy Carter, was a special guest in the Southern 500 parade. Jimmy Carter was elected the 39th US president just two months later. (Above, photograph by T. Taylor Warren, courtesy of Cathy Cross Kirby; below, photograph by A. Terry Josey, courtesy of Terry M. Josey.)

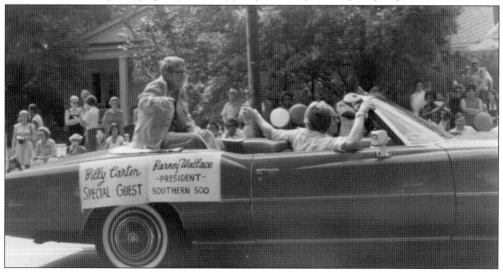

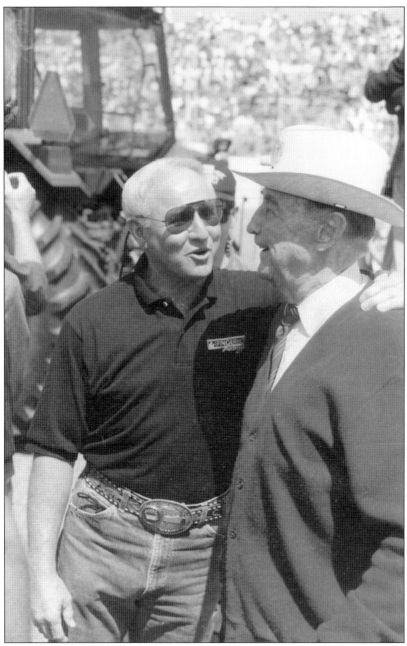

In 1999, a pair of South Carolina legends, Cale Yarborough (left) and Sen. Strom Thurmond, paused for a chat at Darlington Raceway. Yarborough is a member of the NASCAR Hall of Fame and is one of the most successful drivers in history at his "home track." The aspiring young Yarborough was so desperate to compete at Darlington that, in 1957 at age 18, he snuck into the race, which had an age limit of 21. Eventually, NASCAR caught on and threw Yarborough out of the car. Thurmond represented South Carolina in the US senate for 48 years. In 1950, Thurmond, who was governor at the time, and his wife, Jean Crouch, cut the ribbon prior to the inaugural Southern 500. He returned in 1999 to do the same at the race's 50th anniversary. (Courtesy of Darlington Raceway.)

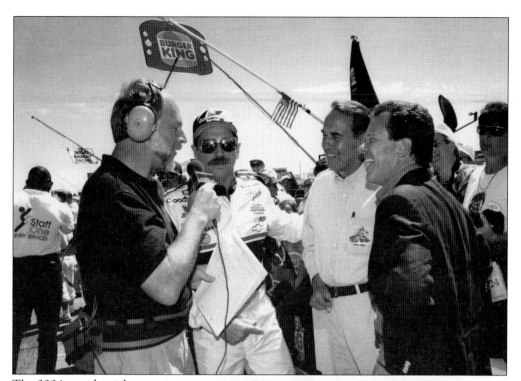

The 2004 presidential campaign gave birth to a new term: NASCAR dads. Fans of the sport are loyal to a fault, and demographic experts working on Pres. George W. Bush's reelection campaign targeted them—the men in particular—with their campaign advertising. They may have been the first to use the term but not the idea. In 1996, presidential hopeful Bob Dole (above, second from right) posed with Dale Earnhardt Sr. (second from left) and South Carolina governor David Beasley (far right) at Darlington. At right, George H.W. Bush is pictured in the track's infield in 1988, prior to being elected the 41st president. The first President Bush was succeeded by Bill Clinton, who also made a stop at the "Lady in Black" while campaigning in 1992. (Both, courtesy of Darlington Raceway.)

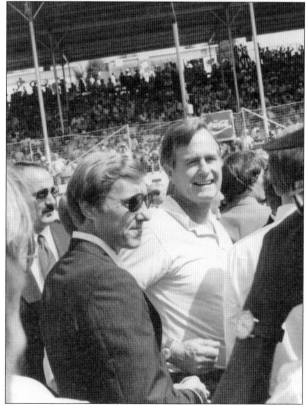

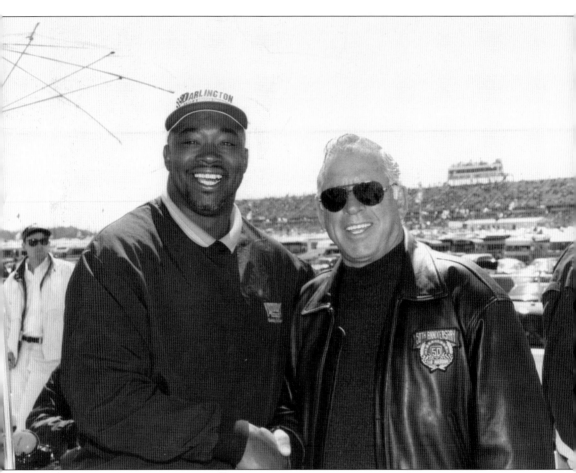

Georgia native George Rogers (left) was an All-American college football player for the University of South Carolina Gamecocks, the 1980 winner of the Heisman Trophy, and the first overall pick in the 1981 NFL draft. Rogers's accomplishments, combined with his friendly, outgoing personality, have made him one of the most popular athletes in South Carolina history as well as one of the most successful. In 1999, Rogers enjoyed the race from the comfort of the Darlington Raceway president's suite along with South Carolina native David Pearson (right), a member of the NASCAR Hall of Fame and Darlington's all-time race winner. (Courtesy of Darlington Raceway.)

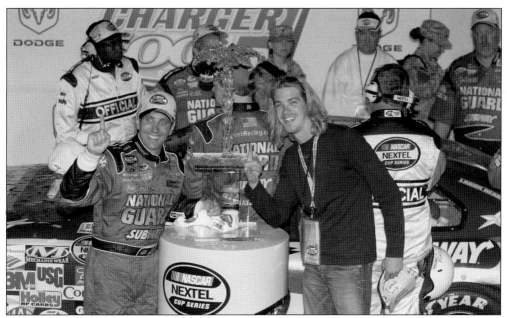

In addition to Darlington Raceway, Harold Brasington also designed Rockingham Speedway. "The Rock" opened its gates in 1965 and offered fans some of the most exciting racing on the NASCAR schedule until 2004. The spotlight once again shone on Rockingham in 2006, when singer Bucky Covington, a native of Rockingham, cracked the top 10 on the hit television series *American Idol*. In May of that year, Covington (right) celebrated in Victory Lane with race winner Greg Biffle. (Courtesy of Darlington Raceway.)

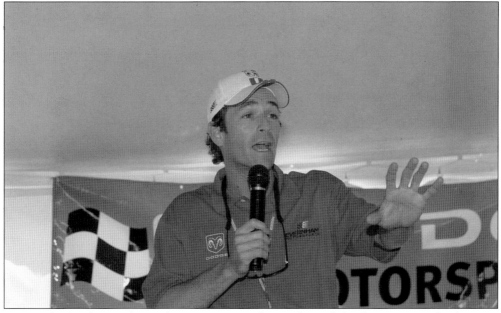

In 2006, the Carolina Dodge Dealers, a race sponsor, hit pay dirt with fans by setting up a date between the "Lady in Black" and one of television's all-time biggest heartthrobs. Luke Perry, who played Dylan McKay on the internationally popular series *Beverly Hills 90210*, spent some time talking with fans before waving the green flag at the Dodge Charger 500. (Courtesy of Darlington Raceway.)

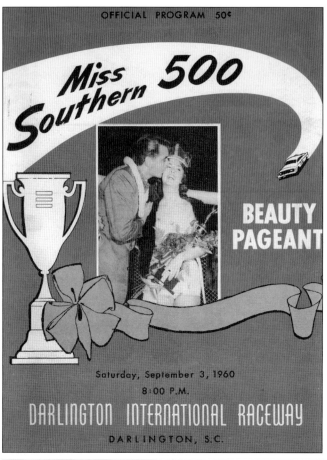

OFFICIAL PROGRAM 50¢

Miss Southern 500

BEAUTY PAGEANT

Saturday, September 3, 1960

8:00 P.M.

DARLINGTON INTERNATIONAL RACEWAY

DARLINGTON, S.C.

Not to be outdone by the cast of *Gunsmoke*, Rory Calhoun, the star of *The Texan*, visited Darlington in 1959. Calhoun was also a popular movie actor whose film credits included Alfred Hitchcock's *Spellbound*, with Lana Turner, and *How To Marry a Millionaire*, with Marilyn Monroe. A photograph of Calhoun kissing Carolyn Melton, winner of the 1959 Miss Southern 500 pageant, graced the cover of the pageant program in 1960 (left). During his first visit to Darlington, Calhoun rode in the lead car for the Southern 500 parade and served as grand marshal for the race. He returned in 1960 to film the movie *Thunder in Carolina* (below), one of the first feature films devoted entirely to the sport of stock car racing. (Left, courtesy of Cathy Cross Kirby; below, photograph by T. Taylor Warren, courtesy of Cathy Cross Kirby.)

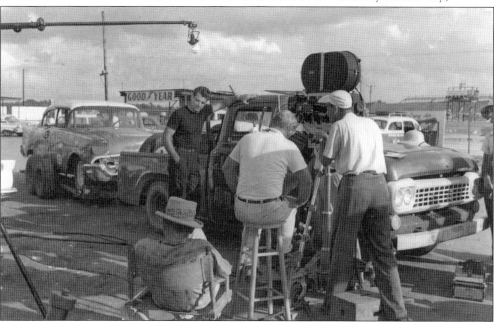

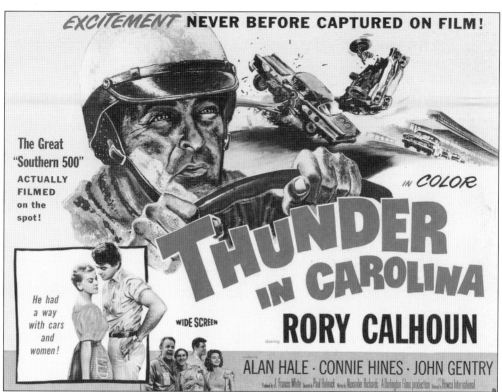

Two notable racing movies have been filmed at Darlington. The first, *Thunder in Carolina* (above), was released in 1960 and starred Rory Calhoun as hotshot racer Mitch Cooper, who takes time off after being injured to mentor an aspiring young driver. The script was based around the Southern 500, and much of the footage was taken during the actual event. (Courtesy of Cathy Elliott.)

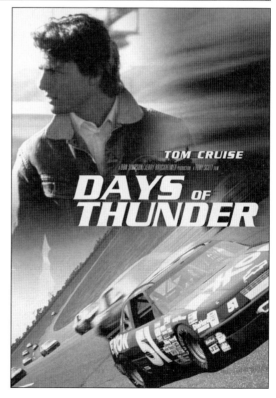

Days of Thunder, released in 1990, starred up-and-coming young actor Tom Cruise and Academy Award-winner Robert Duval in another story about a brash young driver and his wise mentor. Although *Days of Thunder* performed well at the box office thanks to Cruise's rising star power, *Thunder in Carolina* is considered the more authentic of the two films. (Courtesy of Darlington Raceway.)

The Southern 500 parade offered a little bit of everything. Like many small towns in the South, Darlington has a centrally located public square, where much of the town's business is conducted. Thousands of race fans crowded into the square and onto the adjoining streets to watch the parade, which in any given year could include Hollywood celebrities, beauty queens, marching bands, politicians, classic cars, and sponsor representatives like Miss Firebird, seen at left at the speedway. She had her work cut out for her as she had to simultaneously wave, smile, and maintain her balance on the back of a bird. Occasionally, live vignettes were even staged in the street, like the thwarted bank-truck robbery seen below. (Left, photograph by T. Taylor Warren, courtesy of Cathy Cross Kirby; below, courtesy of Darlington Raceway.)

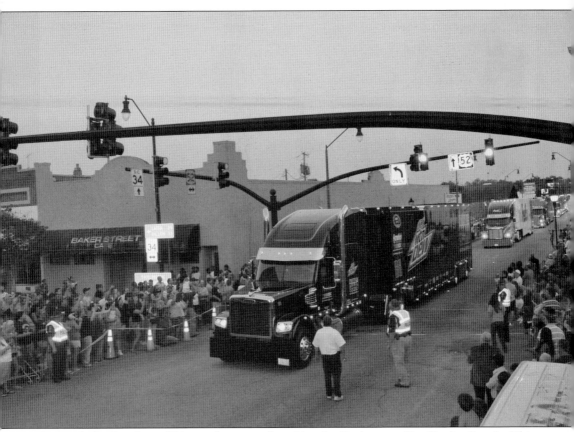

In 2005, the Southern 500 parade was replaced by the Darlington Car Hauler Parade. This nighttime event, held on the Thursday evening before the Saturday night race on Mother's Day weekend, kicks off in the neighboring city of Florence. An afternoon festival hosted by the Florence Civic Center offers fans a bird's-eye view of the haulers used to transport the race cars, a chance to meet racing celebrities, live music, and plenty of food. At dusk, the haulers line up and head to Darlington, where they cruise single-file through the public square with their lights blazing and horns blasting. This relatively new event attracts thousands of fans and has become one of the most popular features of the Bojangles' Southern 500 weekend. (Photograph by Hunter Thomas.)

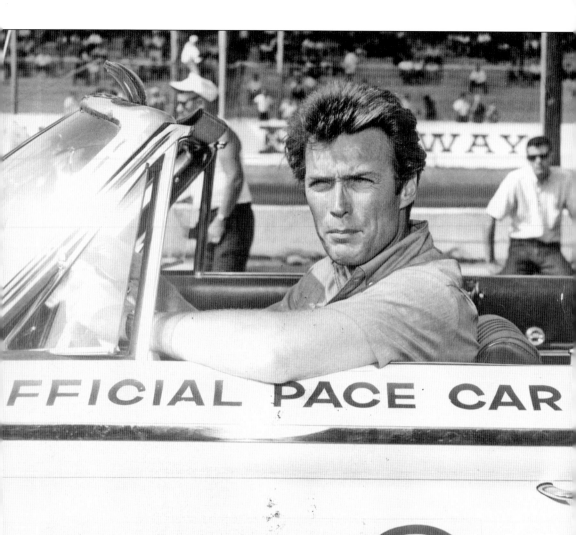

Years before he starred in *The Outlaw Josey Wales* or meted out justice as "Dirty Harry" Callahan or William Munny in *Unforgiven*, Clint Eastwood got some early pistol practice as Rowdy Yates in the top television Western *Rawhide*. Eastwood, like many of his famous predecessors, served as a judge at the Miss Southern 500 Pageant and was grand marshal for the Southern 500 parade. Little did anyone waving at him from the sidewalks surrounding Darlington's public square know that years later, Eastwood would emerge as one of the most respected actors and directors in Hollywood history. But even without the knowledge that one day he would own multiple Academy Awards and even make a foray into politics, Eastwood still made race fans' day in Darlington in 1962. (Courtesy of Darlington Raceway.)

Four

A DAY IN THE LIFE

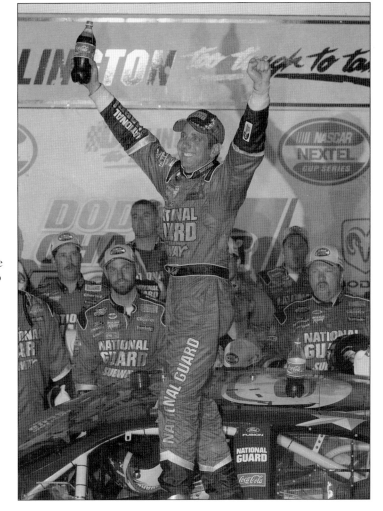

Anyone who thinks drivers sleep late on race day and then climb into the car when race time rolls around is sorely mistaken. Greg Biffle, seen here, won back-to-back races at the track "Too Tough To Tame" in 2005 and 2006 and would be the first to say that the duties of a Darlington champion and his team can make for a very long—but often rewarding—day. (Courtesy of Cathy Elliott.)

Greg Biffle makes a fan's day by taking time to pose for a photograph. The NASCAR garage is the equivalent of an all-access pass, offering those lucky enough to score passes the opportunity to see, and sometimes even talk with, the racing superstars they enjoy watching on television each weekend. (Courtesy of Darlington Raceway.)

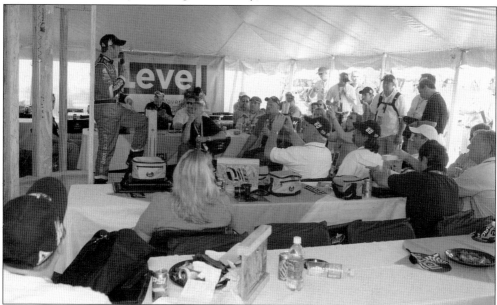

A driver's day often begins with an early visit to the track's hospitality village, where corporations and businesses that sponsor race cars often purchase tents to entertain their customers before the race. The highlight of the hospitality experience is a personal appearance by a driver. Here, Biffle takes questions from the crowd and then signs a few autographs before heading back to the garage. (Courtesy of Darlington Raceway.)

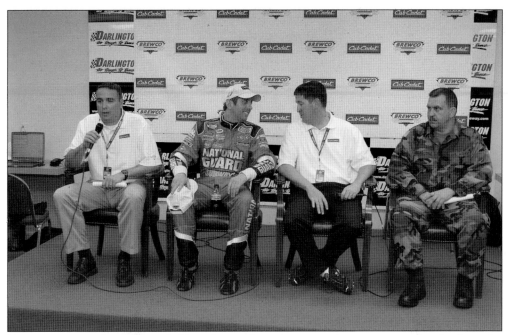

Various press conferences are held in the track media center during race weekend, where the people who regularly cover motorsports—both the action on the track and the business off it—are assembled in one spot. Here, Greg Biffle joins representatives from lawn equipment manufacturer Cub Cadet for an announcement regarding his team. (Courtesy of Cathy Elliott.)

Sponsors know that visibility on a stock car, especially when it is manned by one of NASCAR's top-tier drivers, will exponentially increase their product's exposure. A cool paint scheme, like the one being unveiled here, does not hurt either. (Courtesy of Darlington Raceway.)

There are times when the NASCAR garage (above) strongly resembles the bat cave, with its equipment standing ready until it is needed. As the race draws closer, the team puts final touches on the car, making sure that when that time comes, everything will be in top working condition. (Courtesy of Darlington Raceway.)

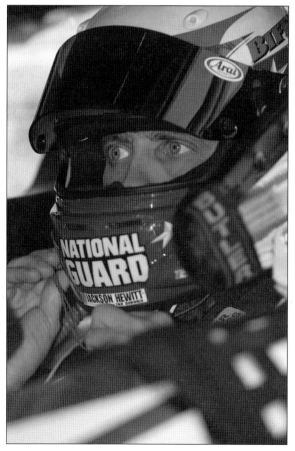

It takes a few minutes to get everything settled inside the car. Safety harnesses must be securely fastened, radio communications tested, and the steering wheel locked into place. Here, with his pre-event preparations completed, Biffle is focused and ready to race. (Courtesy of Darlington Raceway.)

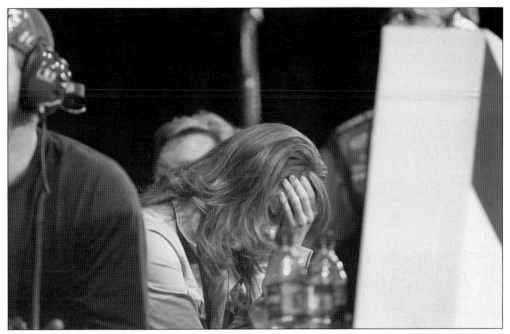

Races at Darlington are always exciting, but that excitement can create some tense moments for the family and friends of drivers. Here, Greg Biffle's wife, Nicole, cannot bear to watch as her husband executes a risky pass during the final laps to take the race lead. (Courtesy of Darlington Raceway.)

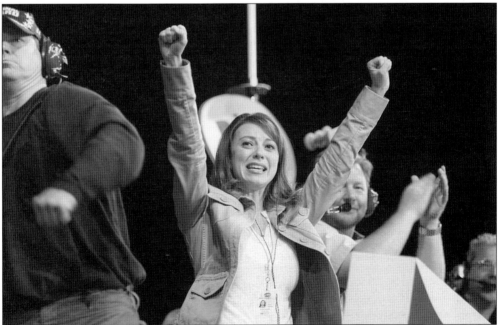

Images of supportive family members suffering through the ups and downs of a race while sitting on top of the pit box—and being showcased on national television—have become a common sight. It is especially nice to see such a moment when the evening ends on a high note, as this one did for Nicole, with her husband heading to Victory Lane. (Courtesy of Darlington Raceway.)

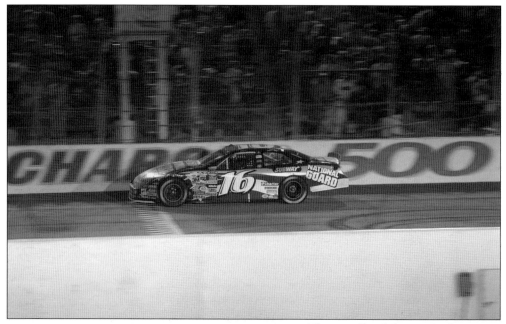

The start/finish line at Darlington Raceway has a history all its own. Looking at the list of the legendary drivers and iconic cars that have crossed it is like taking a walk through the history of NASCAR. When the track was dug up and resurfaced prior to the 2008 Dodge Challenger 500, a piece of the old start/finish line was carefully removed and preserved; it can now be appreciated by visitors to the Darlington Raceway Stock Car Museum. Earning the victory in a NASCAR race is such an intensely emotional and physical experience that at times it can feel almost surreal. Drivers often remark that particular wins might not really register until they see it in writing. At left, the scoring tower confirms the start/finish line's visual results (above), as Greg Biffle's No. 16 car beat Jeff Gordon to earn the victory. (Both, courtesy of Darlington Raceway.)

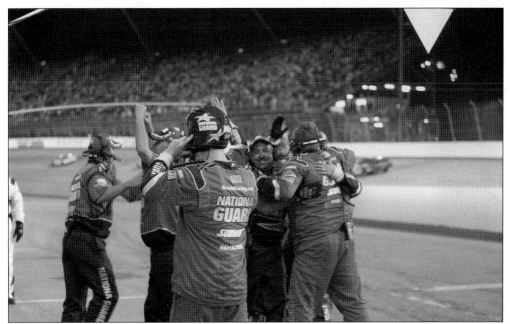

In the modern era of racing, a lot of emphasis has been placed on parity in cars. The days when a single car could win 10 or more races in a season are largely over. The machines are now so equal, and their drivers so skilled, that NASCAR Sprint Cup Series wins are increasingly difficult to earn. When it does happen, members of the crew are not afraid to show their emotion. Here, Biffle's excited team members give each other a hug. (Courtesy of Darlington Raceway.)

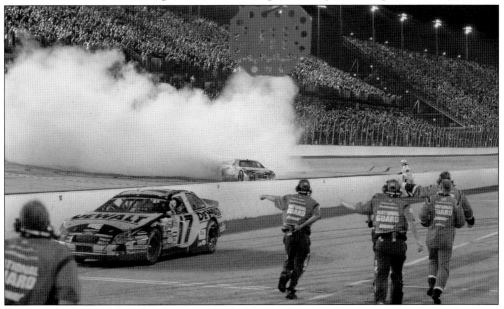

The team members then head to Victory Lane, stopping on their way down pit road to give their driver (in the background) a celebratory salute as he performs a burnout. Burnouts, often referred to as "laying down some rubber," are wildly popular with race fans. Team owners are not quite so enthusiastic, as the maneuver does not do race cars any structural favors. (Courtesy of Darlington Raceway.)

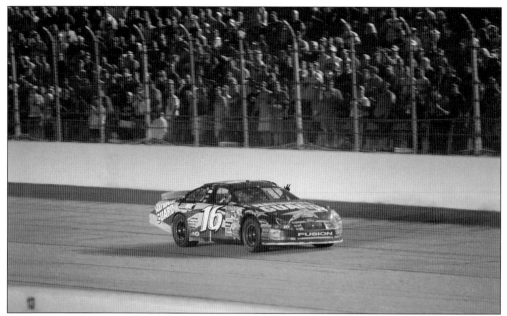

After the field takes the checkered flag to signal the end of a race, the cars come back around the track and down pit road to the garage. At Darlington, it is customary for the race winner to remain on the track for a solo victory lap. Here, Biffle lowers his window net and gives a wave to thank the fans for their support as he circles the 1.366-mile track before heading to Victory Lane. (Courtesy of Darlington Raceway.)

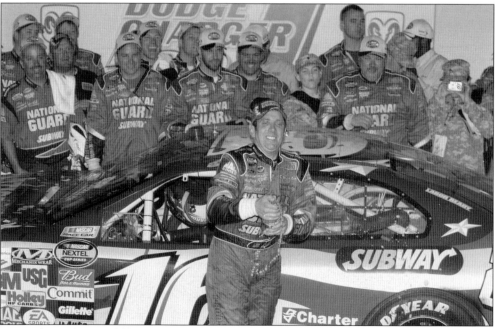

Drivers know they would be at a standstill without the efforts of their team, and group photographs are a standard part of Victory Lane celebrations. NASCAR is a true team sport, and each individual driver recognizes his team members and showers them with thanks, credit, and usually a bottle of champagne after a win. (Courtesy of Darlington Raceway.)

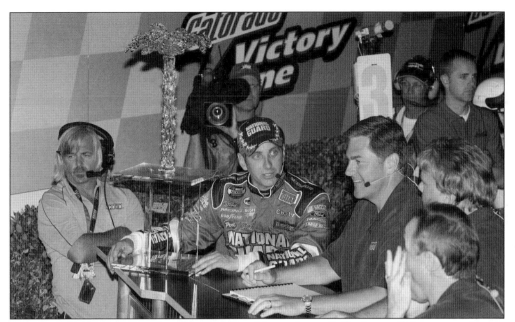

During a television interview broadcast live from Victory Lane, Biffle shows off the newest addition to his trophy case. Darlington has a tradition of commissioning unique trophies that are indicative of the track's history and locale. In this case, the trophy is a beautiful, custom-designed crystal palmetto, the state tree of South Carolina. (Courtesy of Darlington Raceway.)

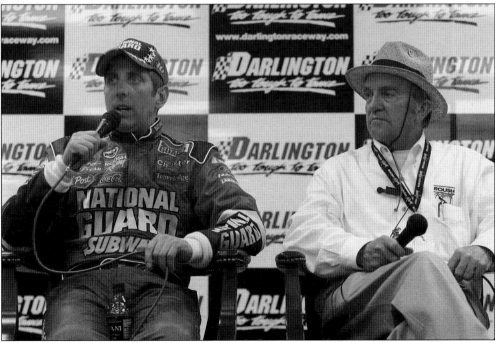

After each race, the winning driver spends substantial time with the media, including an intense question-and-answer period about the action that occurred during the event. When the Victory Lane celebration at Darlington ends and it is time to go back to work, Biffle is joined here at the postrace press conference by his team owner, Jack Roush. (Courtesy of Darlington Raceway.)

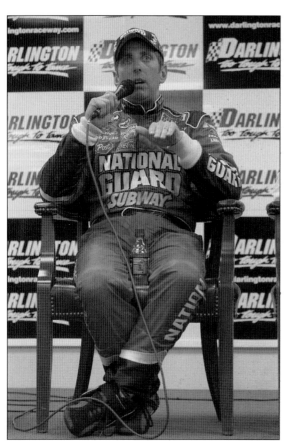

One trait most drivers have in common is "talking with their hands." Biffle verbally describes, and visually demonstrates, how he worked his way to the front of the field at Darlington Raceway and stayed there. "This place is all about track position . . . and survival," he said. (Courtesy of Darlington Raceway.)

Night racing makes for a very long day, as hospitality appearances, interviews, and other obligations generally start around 9:00 a.m. and the race does not end until 11:00 p.m. For the winner, however, the effort is more than worth it. Below, at the end of the day, Biffle, the tired but happy Darlington champion, enjoys a quiet moment in Victory Lane with his wife. (Courtesy of Darlington Raceway.)

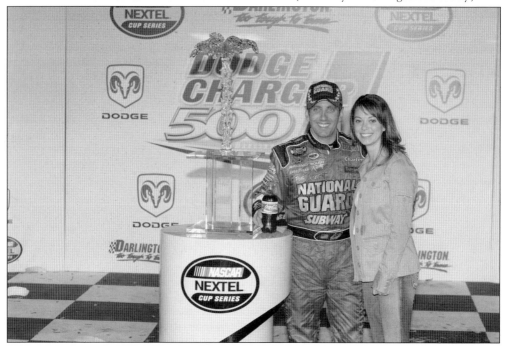

Five
RACE DAY

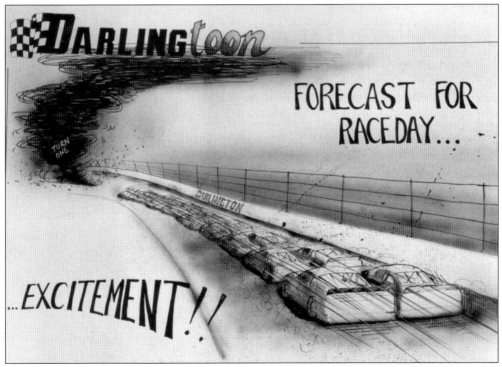

In the 1990s and early 2000s, Darlington Raceway commissioned Florence, South Carolina, artist Jerry Ayers to produce a series of original cartoons featuring the track and her events. Called "Darlingtoons," the best known of them depicted "Hurricanes" Dale Earnhardt and Terry Labonte converging to stir up a late-summer storm at Darlington—the two drivers had tangled at Bristol Motor Speedway the week before. This cartoon nicely sums up the general consensus about the Darlington Raceway experience. (Courtesy of Darlington Raceway.)

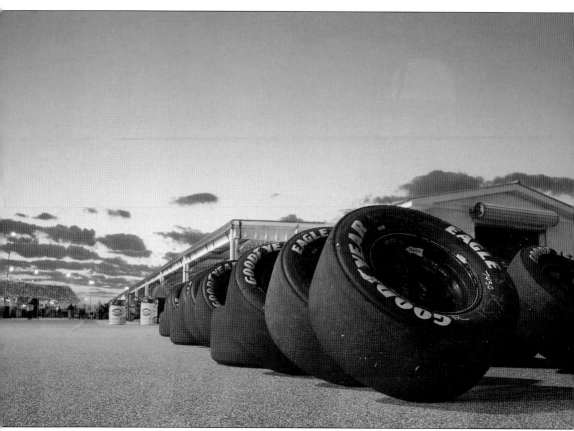

Even for a track that hosts its races at night, the workday begins early in the morning as the garage opens and the drivers get busy fulfilling various obligations. Fans crowd the souvenir and concourse areas, where there is usually an interactive display demonstrating just how difficult it is to lift a tire and change it in a matter of seconds. Racing tires are not "one size fits all." As the surfaces of race tracks are so different and temperatures vary widely according to the track's location and the time of year, Goodyear develops a variety of tire compounds to be used at specific tracks. The tires used at Darlington Raceway are extremely different from those used at, for example, Daytona International Speedway. Here, a row of custom Goodyears sits quietly at Darlington, waiting to go to work. (Courtesy of Darlington Raceway.)

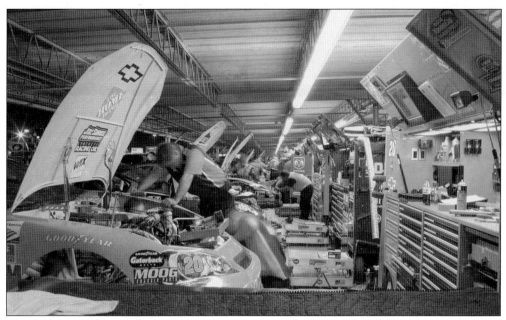

The slightest malfunction of any piece of equipment, whether it is located on the race car itself or is part of the pit crew's high-tech assortment of tools, can make a driver's day go horribly wrong. Everything on the car, from the engine, which can be capable of producing almost 850 horsepower, all the way to the lug nuts on the tires, is checked and rechecked before the start of the race. Teams know from experience that the smallest detail can make the difference between a trip to Victory Lane and a very bad day. The same holds true for the peripheral equipment, which includes everything from sophisticated high-compression air guns to that old standby, duct tape. Below, a crew member checks the fitting on a Sunoco gas can. When completely full, gas cans weigh approximately 100 pounds. It takes roughly 12 seconds to transfer the 18 gallons of fuel from the can to the car. (Both, courtesy of Darlington Raceway.)

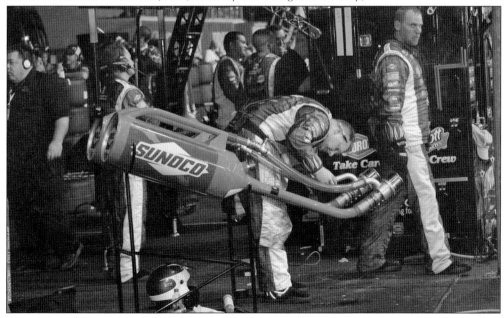

While it is rare, NASCAR drivers occasionally fail to miss their marks, overshooting their pit boxes and losing valuable seconds in the process. To give their drivers some visual assistance, teams employ their own unique style of "exterior decorating" on race day (above), matching the look of the pit stall to the paint scheme on the car. (Courtesy of Darlington Raceway.)

Hundreds of flags flutter in the infield and wave from the grandstand. They vary in size and color but have one thing in common: allegiance. From the Stars and Stripes to military flags and banners bearing the names and likenesses of car manufacturers and drivers past and present, NASCAR enthusiasts comprise the most loyal fan base in professional sports. (Photograph by Hunter Thomas.)

Car haulers are two-storied machines. Two stock cars travel on the top level, while the bottom is a comfortable—if a bit cramped—living space that generally includes a lounge area and a small kitchen. Since the haulers are parked next to the garage, drivers and their team members take advantage of the haulers to cool off, grab a sandwich, or just enjoy a few moments of peace and quiet before taking to the track. Occasionally, a few lucky fans, like the ones seen above with driver Carl Edwards, have the opportunity to get a peek inside the hauler and a coveted autograph. To the younger generation of Edwards fans, like the child at right, autographs do not mean much yet. They just like to have a great time at the track. (Both, courtesy of Darlington Raceway.)

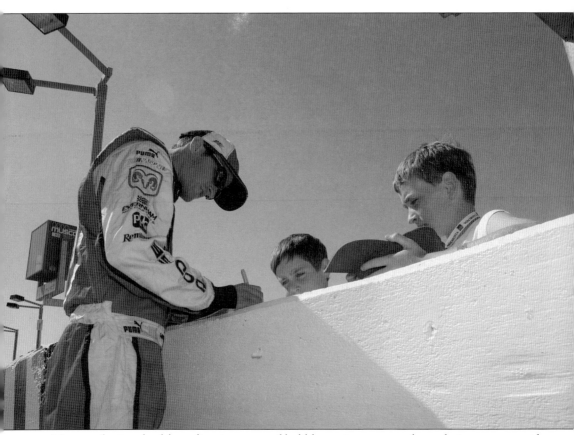

Most professional athletes live in a sort of bubble environment, where their teams provide private locker rooms and personal bodyguards to shelter them from the public. NASCAR takes a completely different approach, not only allowing but also actively encouraging interaction with the fans. Many race-goers have pit passes and even garage access, allowing them to literally rub shoulders with the drivers. Autograph opportunities are so abundant that drivers have fallen into the habit of carrying permanent markers around in their pockets. Proximity and access to the stars of the sport has played a huge role in the growth of NASCAR's mainstream popularity, particularly with kids, who after experiencing personal contact with a driver, feel that he is their friend. Here, Kasey Kahne pauses to sign a few items for a couple of young fans on pit road. (Courtesy of Darlington Raceway.)

Important business-related announcements are sometimes made on race day. In this 2006 press conference at Darlington Raceway, drivers Michael Waltrip (left) and three-time Darlington champion Dale Jarrett announced that they would be leaving their respective teams to become the faces of Toyota's new NASCAR Sprint Cup Series program, which was launched in 2007. (Courtesy of Cathy Elliott.)

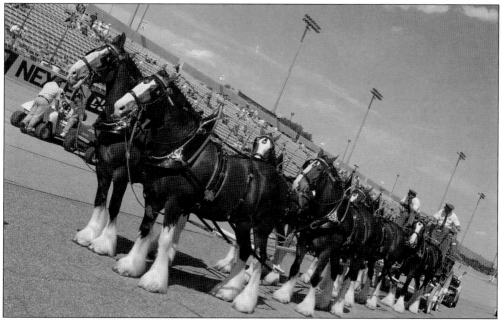

Not all race-day activities are quite so serious. The world-famous Budweiser Clydesdales' mobile stable facilities are often set up near the race track, and the magnificent horses participate in prerace festivities by taking a lap around the track. The crowd-pleasing Clydesdales are not as fast as stock cars, but they pack plenty of horsepower. (Courtesy of Darlington Raceway.)

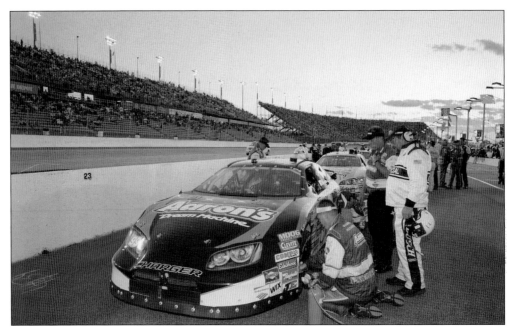

After clearing the prerace inspection process, the field is lined up—or "gridded"—behind the pit wall to await the start of the race. Up to the very last minute, team members go over every detail of the car. A NASCAR official stands nearby to oversee the process, as no changes can be made once the inspection process is complete. (Courtesy of Darlington Raceway.)

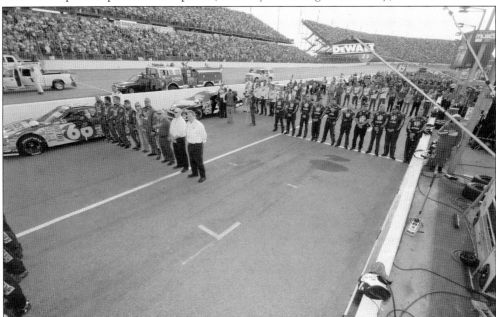

Prior to each race, an invocation is delivered, asking for the safety of the drivers. The national anthem is performed, and in most cases, one or more jets or other military aircraft treat the crowd to a flyover, getting the event off to a rousing start. During the prerace ceremonies, teams line up on pit road, enjoying a final moment of respite before the busy hours that lie ahead. (Courtesy of Darlington Raceway.)

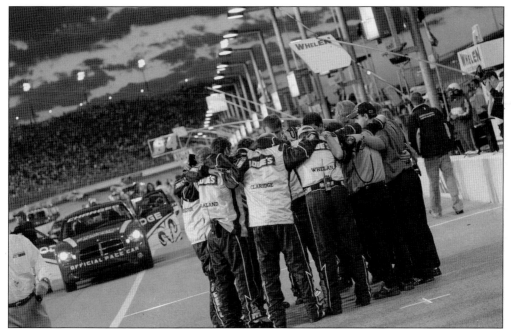

As the pace car pulls to the end of pit road to lead the field around the track, team members generally give one another some last-minute encouragement before the heat of battle begins. Here, the No. 48 Lowe's team huddles up for a late pep talk, or possibly even a prayer. (Courtesy of Darlington Raceway.)

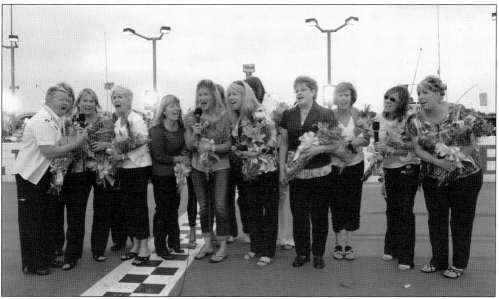

In 2005, Darlington Raceway's annual NASCAR race weekend was moved from Labor Day to the second weekend in May, which traditionally had been an "off" weekend, to allow NASCAR families to be together. Darlington embraced the new date, inviting the drivers' moms to serve as the grand marshals and coming together as a group to deliver the most famous words in motorsports, with a unique Mother's Day twist: "Sons and gentlemen, start your engines!" (Courtesy of Darlington Raceway.)

As the drivers head to their cars and the teams head to their pit boxes, fans head to their individual vantage points to watch the race. NASCAR fans are very creative where their personal "suites" are concerned. A stroll through the infield showcases engineering feats of all levels, from homemade viewing stands situated on the tops of converted school buses to tiered bleachers in the beds of pickup trucks. Those without the advantage of height can settle in for an up-close-and-personal view of the action thanks to giant Sprint Vision screens, or jumbotrons, located throughout the infield. (Above, courtesy of Cathy Elliott; below, photograph by Hunter Thomas.)

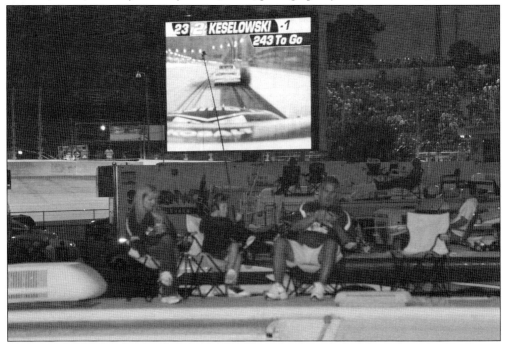

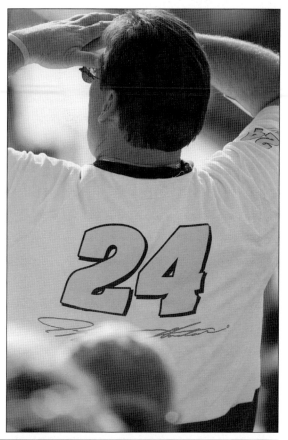

Reserved seating at Darlington is available in five different grandstands. Four of them—the Colvin, Wallace, and Brasington Grandstands and the Tyler Tower—are named after former Darlington Raceway presidents. The fifth, Pearson Tower, gets its name from David Pearson, the most successful driver in Darlington Raceway history. The grandstands provide tens of thousands of individual seats for race patrons, but they are seldom used. Race fans spend the majority of most events standing up, like the one pictured at right, never losing sight of their favorite drivers—in this case, Jeff Gordon in the No. 24 Chevrolet (below). (Right, courtesy of Darlington Raceway; below, photograph by Hunter Thomas.)

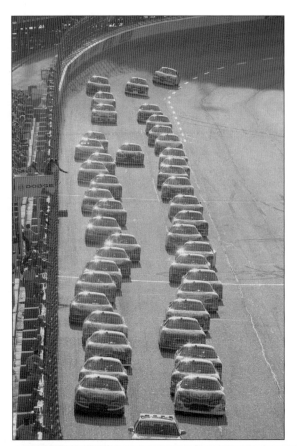

The field of 43 cars heads out of turn four and down the front straightaway toward the flag stand. After the green flag waves to signal the start of the race, the Southern 500 at Darlington Raceway is officially under way. The pace car, which kept the cars at a controlled speed of 65 miles per hour during the warm-up laps, pulls down pit road as the drivers hit the gas headed into turn one. Turns one and two comprise the wider end of Darlington Raceway. The racing surface narrows coming through turns three and four to create the track's famous "egg" shape. (Left, courtesy of Darlington Raceway; below, photograph by Hunter Thomas.)

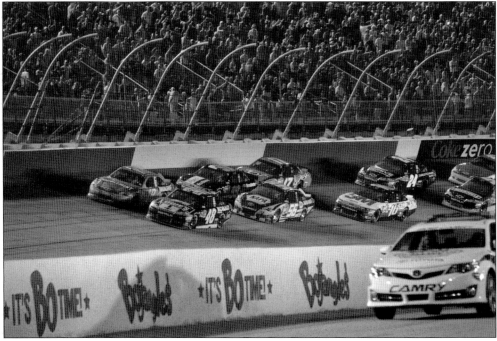

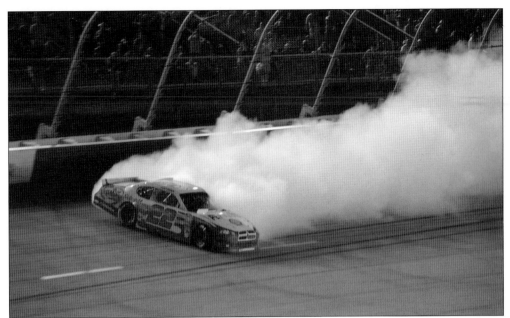

On-track action at Darlington Raceway rarely runs smoothly. Success at Darlington requires patience, which is difficult to maintain while driving 165 miles per hour, mere inches from both the wall and the other competitors. Here, in the 2011 SHOWTIME Southern 500, Kurt Busch loses control of the No. 22 Dodge, spins out midway through the race, and is forced to head to the pits. Thankfully, no other cars were involved. (Photograph by Hunter Thomas.)

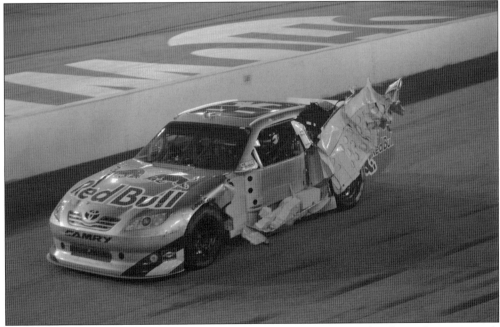

Just two laps later, Brian Vickers in the No. 83 car, who had led the race briefly, made contact with another car, which literally peeled the side off Vickers's Red Bull Toyota. Television broadcaster Darrell Waltrip, a former NASCAR champion, said Vickers's car "looked like it was hit with a can opener." (Photograph by Hunter Thomas.)

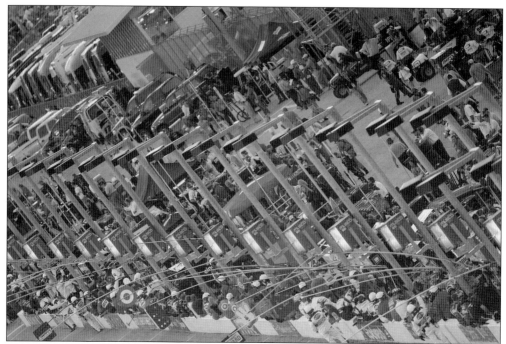

Accidents on the track usually bring out the yellow caution flag, which lets drivers know the race speed will be decreased to a uniform 65 miles per hour for some length of time. During the caution period, pit road becomes a sea of waving signs (above) as most teams take advantage of cautions to bring the cars in for tires, fuel, or other needed work. While the teams take care of the race cars, safety crews take care of the track (below), making sure it is free of excess dirt, debris, oil, or any other outside factors that could cause trouble when the event goes back to green-flag racing. (Both, courtesy of Darlington Raceway.)

Pit stops are tense affairs, requiring a large amount of work to be completed in a very brief period of time. Speed is critical, as race positions can be gained or lost in the pits, and tempers can flare, creating dramatic—and popular—story lines for fans to follow. After an altercation between Kyle Busch and Kevin Harvick in 2011, Darlington Raceway used the two drivers' images on billboards advertising the following year's race (above). NASCAR officials maintain a constant presence on pit road during races, their duties ensuring that the team members remain inside the boundaries of the pit stall during pit stops and that no debris or loose equipment is left in the stall when the pit stop is complete. Officials will even help teams chase down a loose tire, if the situation arises. (Both, courtesy of Darlington Raceway.)

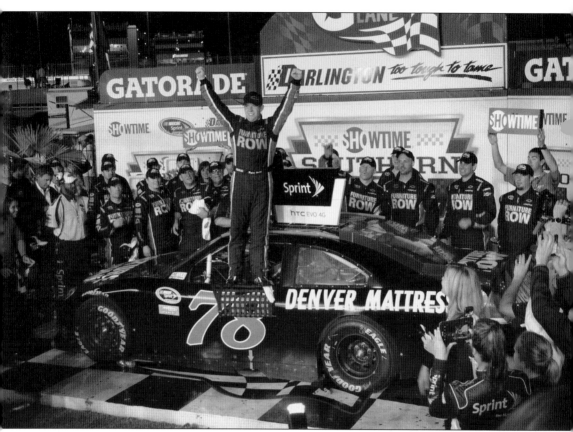

At the end of the evening, only one driver can take up residence in Victory Lane. In 2011, that driver was Regan Smith, who claimed the first NASCAR Cup Series win of his career at Darlington, the first driver to do so since 1988, when Lake Speed accomplished the same feat. "This is the Southern 500; we're not supposed to win this thing," Smith said during his Victory Lane interview. "This race is so special and so meaningful. We were standing there looking at the names and the faces on the trophy. It has all the past Southern 500 winners on there, and you just look at it and think, 'My face is going to be there, right next to these guys, and it'll be there forever.'" (Photograph by Hunter Thomas.)

Six

EVEN STOCK CARS
GET A DAY OFF

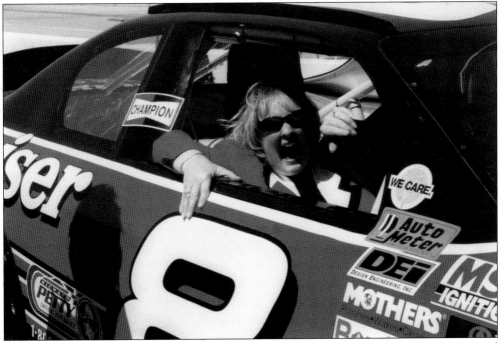

Darlington Raceway has played host to a number of nationally known riding experiences and driving schools over the years, operated by big names like Buck Baker, Richard Petty, and NASCAR. Racing schools allow fans to experience authentic NASCAR action, either as a passenger or behind the wheel. Jane Pigg, a normally calm local radio executive and newspaper publisher, had a lively reaction to her first taste of real speed during a Richard Petty Driving Experience ride-along. (Courtesy of Darlington Raceway.)

NASCAR Hall of Famer David Pearson (left) is the most successful driver in Darlington Raceway history, and even retirement could not slow him down. In 1998, the track introduced the David Pearson Darlington Riding Experience, with the "Silver Fox" driving brave participants around the track at an average speed of 150 miles per hour. "You might get me to go slower," Pearson said. "But you might not." The program was introduced at a press conference that gave bolder media members a chance to experience the ride firsthand before writing about it. Below, track president Jim Hunter and former South Carolina governor David Beasley joined Pearson for the official unveiling ceremony. (Both, courtesy of Darlington Raceway.)

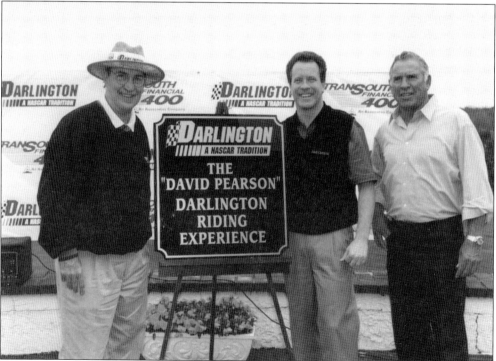

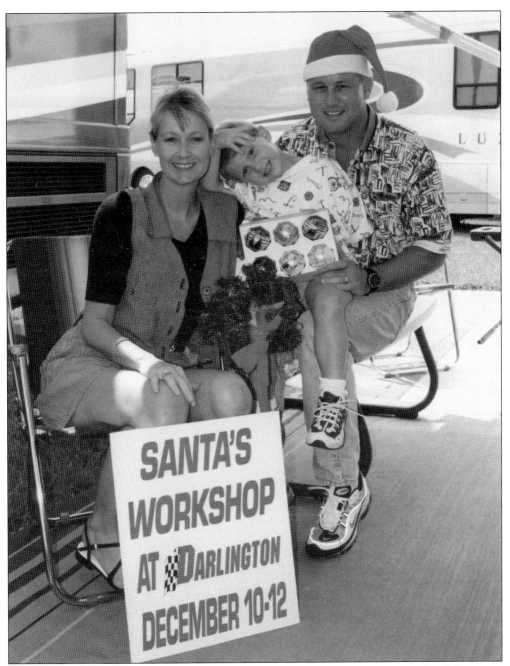

SANTA'S
WORKSHOP
AT DARLINGTON
DECEMBER 10-12

It takes a full year to plan and execute a NASCAR Sprint Cup Series race weekend, but some months are busier than others. For several years, the track hosted "Santa's Workshop" to raise money for local charities during the holiday season. The annual three-day event included hundreds of thousands of twinkling lights strung around the facility; self-guided tours through infield buildings filled with trains, dolls, and other Christmas experiences; and hayrides around the track. Although thoughts of Christmas cheer were few during the hot Southern 500 Labor Day weekend, driver Ricky Rudd donned his Santa hat and encouraged infield fans to return in December for a trip to Santa's Workshop. (Courtesy of Darlington Raceway.)

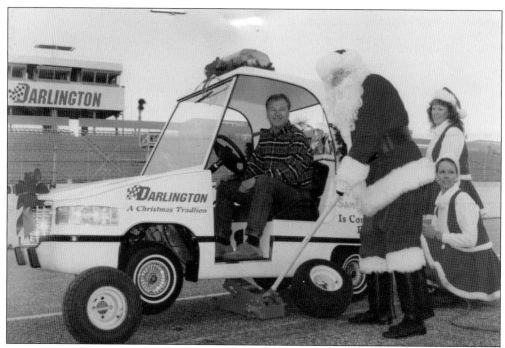

Former NASCAR Slim Jim All-Pro Series champion and Darlington native Hal Goodson, driving a special Christmas golf cart, got some quick service during a pit stop at Darlington Raceway to promote Santa's Workshop. Santa served as the jack man while his lovely elves changed the tires and topped off the gas tank. (Courtesy of Darlington Raceway.)

After months spent working to create a winter wonderland in the infield, raceway staffers and community members were pressed into a few days' service as elves and even a cheery Mrs. Claus, serving cookies and cocoa during Santa's Workshop, a practice that some wryly contend led to the eventual demise of the event. (Courtesy of Darlington Raceway.)

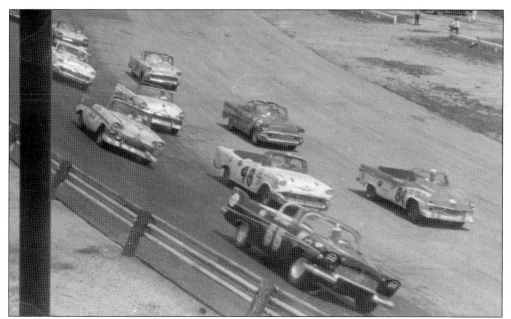

In 1957, Darlington Raceway began hosting two annual races. NASCAR had formed a Convertible Division in 1956, and the 1957 convertible race at Darlington was the series' largest event to date. The race, scheduled for a Saturday, was rained out. South Carolina's blue laws prohibited any retail activity on Sunday, but violating the law carried only a $50 fine, so raceway president Bob Colvin paid the fine and ran the race on Sunday. (Courtesy of Darlington Raceway.)

Race fans across America had something to get excited about when NASCAR introduced the NASCAR SuperTruck Series Presented by Craftsman (now the NASCAR Camping World Truck Series), which first raced at Darlington in 2001, quickly earning a reputation for aggressive, hard-charging action on the track. Given Darlington's "Too Tough To Tame" nickname, the two were a perfect match. (Courtesy of Darlington Raceway.)

In September 2008, Darlington Raceway debuted the Darlington Historic Racing Festival. The two-day event featured question-and-answer sessions with racing legends, exhibition laps by historic race cars from each era in Darlington's history, autograph sessions, display and vendor areas, a custom car corral featuring hot rods and streetcars, a kid zone, a swap meet with hundreds of vintage and modern parts, and a variety of other activities. Chris Browning, the president of Darlington Raceway, said the goal he had in mind for the festival was "creating an event which will highlight and showcase the storied oval-track end of the vintage racing market for stock cars and IndyCars, much like Monterey and Road America have done for road courses catering to the sports car vintage market." The event ran from 2008 to 2010. (Courtesy of Darlington Raceway.)

The name David Pearson comes up again and again in stories about Darlington Raceway, but almost as well known as the driver's name is his car number. Pearson drove the No. 21 car to Victory Lane 43 times between 1972 and 1978. The car was a popular display at the Darlington Historic Racing Festival. (Photograph by Hunter Thomas.)

A major attraction of the Historic Racing Festival was the opportunity to meet racing legends and hear them talk about their experiences. Pictured here are, from left to right, broadcasting great Barney Hall; 1965 Southern 500 champion and NASCAR Hall of Famer Ned Jarrett; "Handsome Harry" Gant, winner of the Southern 500 in 1984 and 1991; and legendary team owner and NASCAR Hall of Famer Leonard Wood. (Photograph by Hunter Thomas.)

In 2007, Darlington's Mother's Day race weekend added a bonus event for fans: a United States Auto Club (USAC) Silver Crown Series event. The race marked the first time in 51 years that USAC cars had competed at Darlington Raceway. The open-wheel Silver Crown cars (above), substantially smaller and lighter than NASCAR's stock machines, put on an exciting show at Darlington, as Indiana native Aaron Pierce led a three-car freight train to take the checkered flag. NASCAR stars who won Silver Crown Series championships racing USAC cars early in their careers include Jeff Gordon, Tony Stewart, and Ryan Newman. At left, Newman offers some last-minute advice to driver Brian Tyler (center). (Both, photographs by Dwight Drum, courtesy of racetake.com.)

Open-wheel cars like the ones competing here may look a little out of place on the high banks of Darlington Raceway, but they raced at the "Lady in Black" in her inaugural season. The winning car was "Basement Bessie," a homemade machine built in the basement of its regular driver, Paul Russo, by Russo and his chief mechanic, Ray Nichels. In a textbook example of working under challenging logistical conditions, the car had to be dismantled for removal from the basement, then put back together in order to race. Russo and Bessie competed in the 1950 Indianapolis 500. She was considered something of an underdog and caught the imagination of fans, who cheered as Russo raced her right along with the leaders until the race ended due to rain, giving the win to Johnnie Parsons. Ironically, Parsons later filled in for an injured Russo at Darlington and won. (Photograph by Charles F. Banta Jr.; courtesy of Terry M. Josey.)

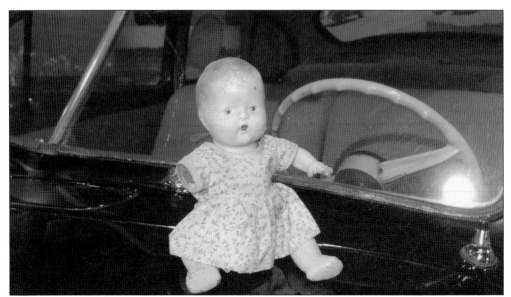

The Darlington Raceway Stock Car Museum, located adjacent to the speedway's administrative offices, is open year-round and houses an impressive collection of stock cars, along with an assortment of interesting and sometimes quirky memorabilia. This doll belonged to the young daughter of NASCAR flagman Alvin Hawkins, a co-owner of the Plymouth that Johnny Mantz drove to victory in the 1950 Southern 500. The little girl offered her beloved toy to Mantz for good luck after he qualified the car in the very last position, and the doll rode shotgun during the race, securing a place in history by being a part of the first car to ever win at Darlington. The museum is also the official home of the National Motorsports Press Association (NMPA) Hall of Fame, which includes drivers, owners, crew chiefs, promoters, sponsors, and others who have made a significant impact on all forms of motorsports over the years. (Both, photographs by Cathy Elliott, courtesy of Darlington Raceway.)

Seven
DEFINING MOMENTS

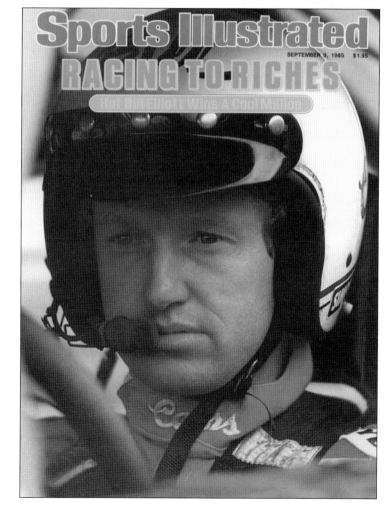

Darlington Raceway, who by her very existence is a vital piece of NASCAR history, has been the setting for many memorable moments since 1950. Perhaps none is more indelibly linked with the track than Bill Elliott's win in the 1985 Southern 500. The victory earned Elliott a $1 million bonus and put NASCAR on the cover of *Sports Illustrated* magazine, a rare occurrence in those days. (Courtesy of Cathy Elliott.)

Mark Martin has enjoyed a long and successful career in the NASCAR Sprint Cup Series, but particularly at Darlington, he also made quite a name for himself in the NASCAR Nationwide Series. The NASCAR Nationwide Series is the second most popular form of motorsports in America. Martin, a native of Batesville, Arkansas, finished his first NASCAR Nationwide Series race at Darlington in 1987 an inauspicious 38th, but from that point, it was all uphill. Martin is the all-time wins leader in the series at Darlington, with a record eight trips to Victory Lane. (Courtesy of Darlington Raceway.)

Brian Vickers made his debut in the NASCAR Nationwide Series at the tender age of 17, when he was still a high school student; he was so devoted to his career that he skipped his senior prom to go to a race. He started the fall 2003 NASCAR Nationwide Series race at Darlington about two months shy of his 20th birthday and ended the race not only in Victory Lane, but also in the record books as the youngest winner in Darlington Raceway history. The win gave Vickers, a native of Thomasville, North Carolina, the momentum he needed to win the series championship that season, where he set another record as the series' youngest-ever titleholder. He has gone on to enjoy success in the NASCAR Sprint Cup Series, winning races for Hendrick Motorsports and Red Bull Racing. Known for his attention to detail, Vickers is seen here checking out his Goodyear tires before a race at Darlington. (Courtesy of Darlington Raceway.)

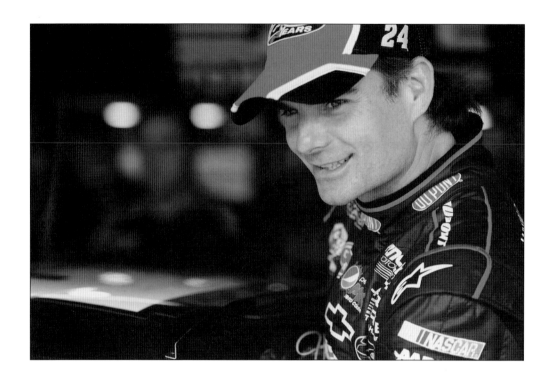

Jeff Gordon blistered into Darlington in 1995 determined to get his first win at the legendary speedway, and that is exactly what he did. It was the first of Gordon's seven career victories at NASCAR's original superspeedway, with five of those wins coming in the Southern 500, tying him with Cale Yarborough for most wins in the fall classic. Gordon has enjoyed a couple of particularly nice paydays at Darlington, holding off Jeff Burton on the final lap to win the second-ever "Winston Million" in 1997 and picking up another cool million in 1998 as part of Winston's "No Bull 5" promotion. In 2001, Darlington Raceway issued a commemorative ticket in Gordon's honor (below). (Above, courtesy of Darlington Raceway; below, courtesy of Cathy Elliott.)

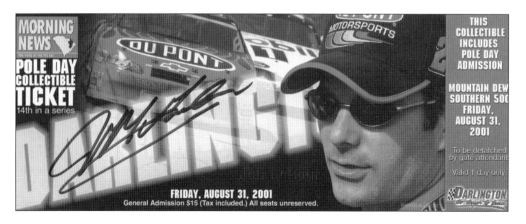

Darlington Raceway celebrated a historic milestone in 1999 with the 50th running of the Southern 500. A packed house turned out to watch the race, but the crowd included one unwelcome guest: rain. When showers made the asphalt too slippery to race on, the event was halted with Jeff Burton in the lead. As the rain continued to fall and daylight began to fade, a hopeful Burton performed what would become known as his "rain dance." Soon afterward, the race was declared over and Burton was named the winner. "You can say what you want about the Daytona 500 or Indianapolis, but as far as I'm concerned, the Southern 500 is the biggest race of the year," he said. Burton swept both events that season. In 2000, his older brother Ward won the March event, following it up with a victory in the 2001 Southern 500 to make the Burtons the only brother duo to win both the spring and fall races at Darlington. (Courtesy of Cathy Elliott.)

Cale Yarborough grew up in the shadow of Darlington Raceway, in nearby Sardis, South Carolina. The man who became known as the "Timmonsville Flash" watched his first race at Darlington in 1951 after finding a loose spot in the fence and crawling underneath. In 1968, he finally took the checkered flag in the Southern 500, going on to win five times at Darlington and becoming one of the track's favorite sons. In August 2004, after he was announced as one of four drivers invited to run the first exhibition lights under Darlington's new lighting system, a fan called from Ohio to verify the information. "Are you really planning to drive 1,000 miles to watch Cale Yarborough drive 10 laps?" a staffer asked. The man replied, "If I had to, I would WALK 1,000 miles to watch Cale Yarborough drive 10 laps." In 1995, the track issued a commemorative ticket featuring Yarborough. (Above, courtesy of Darlington Raceway; below, courtesy of Cathy Elliott.)

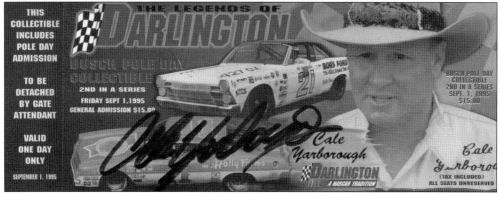

Prior to the 1985 NASCAR season, then series sponsor Winston announced an unprecedented incentive program. Any driver who could win three of the four annual "crown jewel" races—the Daytona 500, the Winston 500 at Talladega Superspeedway, the Coca-Cola 600 at Charlotte Motor Speedway, and the Southern 500 at Darlington Raceway—would be awarded a $1 million bonus. After Bill Elliott won two of the three earlier in the season, it came down to the wire at Darlington, where he won the race and took home the money. In the above photograph, he waves to the delighted crowd after the race. The track subsequently issued a commemorative ticket in Elliott's honor (below). (Above, photograph by Terry M. Josey; below, courtesy of Cathy Elliott.)

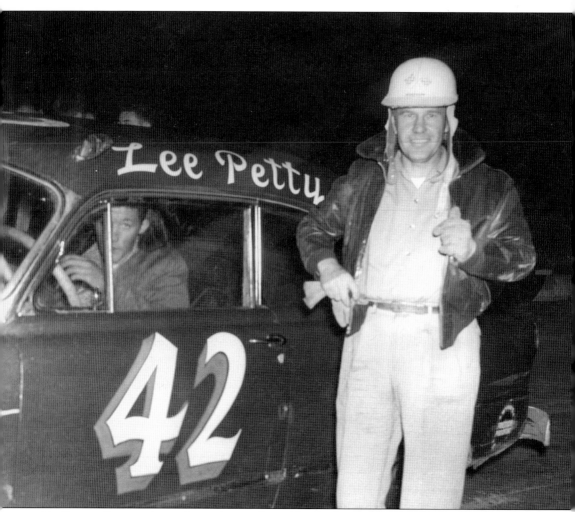

Darlington Raceway has welcomed a number of family dynasties over the years, with the most famous being the Pettys. Lee Petty was a racing pioneer, and even though his career did not begin until he was 35 years old, he became one of the first NASCAR superstars, winning three championships. He is probably best known for a racing controversy that occurred during the inaugural Daytona 500 in 1959, when Petty contested the results after Johnny Beauchamp was declared the winner. Three days later, after careful review of national newsreels and photographs taken at the race, the decision was reversed, and Petty was named the winner. He started in the 35th position in the inaugural Southern 500, finishing sixth. Lee Petty competed in a total of 13 races at Darlington. His highest finish was fourth, in 1960, a year after his son Richard Petty raced in his first Southern 500. (Courtesy of Darlington Raceway.)

The Petty racing tradition continued at Darlington Raceway when Richard Petty (right) competed in his first Southern 500 in 1959, starting sixth and finishing fourth. "The King" was successful overall at Darlington, winning three times, including a sweep of both races in 1967. (Courtesy of Darlington Raceway.)

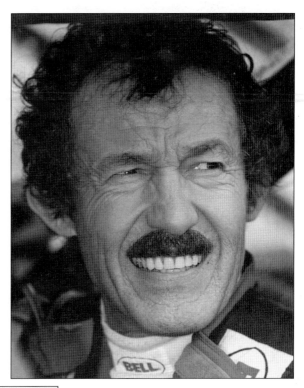

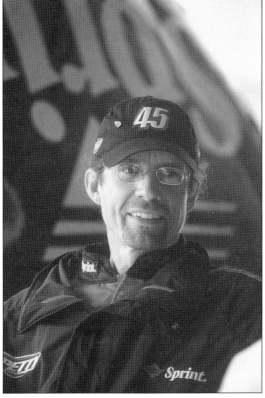

Like father, like son. Richard Petty's son Kyle (left), who first competed at Darlington in 1981, concurs with his dad in regard to Darlington but failed to mirror his success. In 51 starts, Kyle's best finish was sixth place, in the 1991 spring race. (Courtesy of Darlington Raceway.)

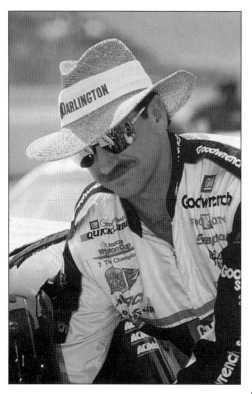

The theme of family tradition is a continuing thread that runs through the history of Darlington Raceway. Dale Earnhardt Sr. loved the track and was one of her biggest supporters, often seen wearing the Darlington straw hat he is pictured in at left. Earnhardt had reason to love Darlington; he won nine races in NASCAR's premier series at the track. Dale Earnhardt Jr. (below), on the other hand, was a bit slower to come around. In an interview with a national magazine, he once famously compared Darlington's racing surface to a cheese grater and claimed the track added seashells to the asphalt mix. "Rub your hand across it; it will literally cut you," he said. The remark was made mostly in jest, as "Junior" is a history buff and has great respect for Darlington Raceway. (Left, courtesy of Darlington Raceway; below, photograph by Jared C. Tilton, courtesy of Harrelson Photography Inc.)

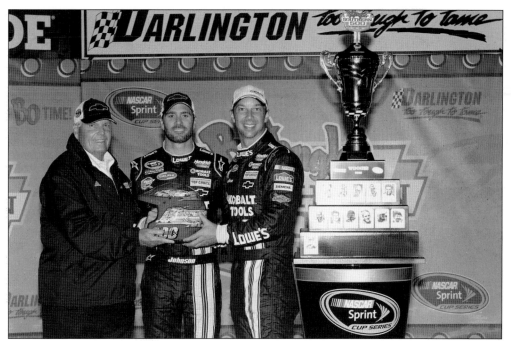

Hendrick Motorsports is one of the most successful organizations in NASCAR history. Owner Rick Hendrick was late for the 2012 Bojangles' Southern 500 at Darlington, as he was attending a friend's wedding. When he finally arrived at the track, only about 100 laps remained in the race, but his driver, Jimmie Johnson, took the lead with 43 laps to go and held onto it until the end, giving Hendrick Motorsports its historic 200th win. (Photograph by Jared C. Tilton; courtesy of Harrelson Photography Inc.)

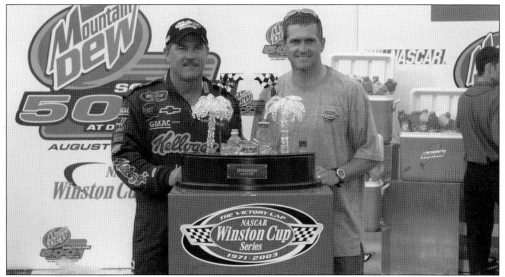

Terry Labonte (left) was the central figure in another historic Hendrick moment at Darlington. Labonte was driving a Hendrick Motorsports Chevrolet in 2003 when he won the final Labor Day running of the Mountain Dew Southern 500. Terry's brother Bobby Labonte (right), the 2000 Pepsi Southern 500 champion, came to Victory Lane for a congratulatory hug and a photograph. (Courtesy of Darlington Raceway.)

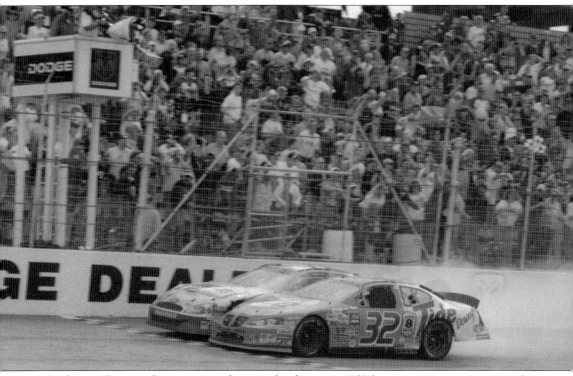

Darlington Raceway has seen many fantastic finishes since 1950, but none were more exciting than the last-lap battle between Ricky Craven and Kurt Busch in March 2003. Busch had dominated the end of the race but was fighting more than his competitors; his power steering had failed and he was literally using brute strength to wrestle the car around the track. Coming out of turn four on the final lap, the two cars were touching, with their doors locked together as they crossed the finish line. Fans and track officials were looking at one another and asking, "Who won?" Craven himself said he had no idea of the outcome until he glanced up at the track scoreboard. After close review, Craven was declared the winner, by two one-thousandths of a second. It was a truly thrilling moment and another Darlington milestone, going into the record books as the closest finish in NASCAR history. (Courtesy of Darlington Raceway.)

Eight
ONLY AT DARLINGTON

Darlington Raceway has earned a reputation for quirkiness in race promotion. Eventually, the drivers gave in and got into the spirit, resulting in classic moments like Denny Hamlin serving up biscuits at a local Bojangles' restaurant (right). It has become commonplace to see a driver, while being recruited for the track's latest promotional scheme, shake his head and say, "Only at Darlington." (Photograph by Samantha Lyles; courtesy of the (*Darlington News and Press.*)

The biggest names and personalities in NASCAR have raced at Darlington through the decades, and fans have flocked to watch their favorites go head-to-head on the legendary track. But NASCAR competition extends beyond the actual race tracks, as track promoters and public relations specialists continually work to find innovative ways to encourage potential ticket buyers to attend races at their venue. For a number of years, Darlington grabbed headlines thanks to the unique trophy it awarded to the fastest qualifier for each race. The sculpted clay feline (left), designed by Hartsville, South Carolina, artist Patz Fowle, became a sort of status symbol in the garage. Drivers like Jeff Gordon and David Pearson (below) claimed their trophy cases were not complete without the addition of the Darlington Raceway "Pole Cat." (Left, photograph by Cathy Elliott; below, courtesy of Darlington Raceway.)

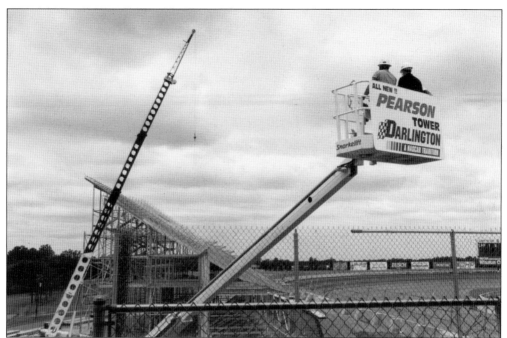

The late Jim Hunter, Darlington's president from 1993 to 2001, had a knack for conceiving attention-grabbing photograph opportunities and enjoyed participating in them. He is seen above arriving at a press conference to dedicate the new Pearson Tower grandstand in the basket of a bucket truck, with David Pearson in tow. (Courtesy of Darlington Raceway.)

He looks fresh out of high school here, but Ricky Craven, posing with sword in hand as he prepares to do battle with Darlington Raceway, went on to make history at NASCAR's original superspeedway. In March 2003, Craven beat driver Kurt Busch to the checkered flag by a margin of .002 seconds, the closest finish in NASCAR history. (Courtesy of Darlington Raceway.)

Seven-time NASCAR Sprint Cup Series champion Dale Earnhardt said he was ready to "whip" Darlington Raceway and notch his record-tying 10th Darlington victory in the 1996 TranSouth Financial 400, the track's spring race. "The Intimidator" had a deep respect and fondness for the "Lady in Black." "You never forget your first love," he said. "Whether it's a high school sweetheart, a faithful old hunting dog, or a fickle race track in South Carolina with a contrary disposition. And, if you happen to be a race car driver there's no victory so sweet, so memorable, as whipping Darlington Raceway." Unfortunately, Earnhardt never got that elusive 10th victory. His final competitive event at Darlington was the 2000 Pepsi Southern 500. (Courtesy of Darlington Raceway.)

Had he won the 1996 Mountain Dew Southern 500 at Darlington Raceway, 1999 NASCAR Sprint Cup Series champion Dale Jarrett would have walked away with a $1 million bonus. In anticipation of the event, he was delivered to the track for a press conference in the back of an armored truck (above). Jeff Gordon, however, won the race. (Courtesy of Darlington Raceway.)

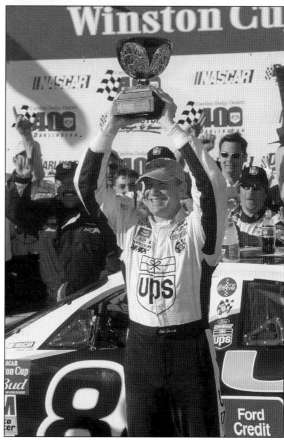

Jarrett finally got that elusive Darlington victory the following year, when he took the checkered flag in the spring race, the TranSouth Financial 400 (right). He followed it up with two more career wins at Darlington, in 1998 and 2001. All three of Jarrett's Darlington victories came in the spring. (Courtesy of Darlington Raceway.)

NASCAR Sprint Cup Series champion Rusty Wallace sends a message to his fans, not wanting them to end up without tickets for the Southern 500. Unfortunately, Wallace, a popular, gregarious NASCAR Hall of Famer, never posted a victory at Darlington. (Courtesy of Darlington Raceway.)

Bill Elliott (below), who was voted NASCAR's most popular driver 16 times, was a five-time Darlington champion and winner of the first Winston Million bonus in 1985. He is pictured here handing out cigars to celebrate the birth of his son Chase in 1995. Chase followed his famous father's career path and is now a talented driver in his own right.

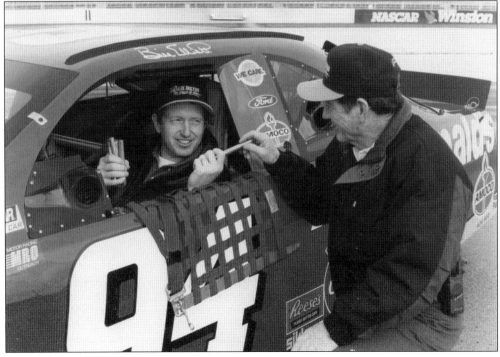

Sterling Marlin places his hands in wet cement so his handprints can be added to the Liberty Lane Walk of Fame. The charming brick side street in downtown Darlington is bordered by two rows of the handprints of winning drivers at Darlington, along with the dates of their victories. Additional dates are added to the prints of drivers who have won multiple events at the track. Marlin, a self-described "countrified" driver who claimed he once accidentally set a cow on fire, is assisted in getting his hands dirty by former Darlington downtown revitalization director Tony DiLeo. Marlin was a two-time winner at Darlington, in 1995 and 2002. (Courtesy of Darlington Raceway.)

Jimmy Spencer, known throughout his racing career as "Mr. Excitement," tried to use a little reverse psychology on Darlington Raceway in 1999, applying his own version of the famous "Darlington Stripe" to his face in anticipation of the event. The scare tactic did not work on the tough old track, however, as Spencer never won a race at Darlington. (Courtesy of Darlington Raceway.)

As the oldest superspeedway on the NASCAR circuit, Darlington does not have the wide, sweeping turns that have been incorporated into new facility construction projects. In fact, Darlington is quite narrow by race track standards, prompting Hut Stricklin (below) to send a message to his fellow competitors in 1997, claiming there was "no vacancy" in turn one. (Courtesy of Darlington Raceway.)

Darlington is a tough dealer; even three-time NASCAR Sprint Cup Series champion Darrell Waltrip said you never know what the unpredictable track can spring on you. Waltrip began his NASCAR racing career in 1972. Aggressive and outspoken, he earned the nickname "Jaws," but it was eventually replaced by the somewhat gentler "Ol' D.W." He won NASCAR championships in 1981, 1982, and 1985 and claimed victory at the Daytona 500 in 1989, where he performed a unique version of the "Ickey Shuffle" touchdown celebration dance in Victory Lane. He was a five-time winner at Darlington. From the look on his face here, he apparently thought the track would be on his side for the 1998 TranSouth Financial 400 as well, but in the end, she preferred Dale Jarrett. (Courtesy of Darlington Raceway.)

Darlington Raceway hosted the International Race of Champions (IROC) Series from 1993 to 1995. The events featured a small field, usually comprised of champions from various motorsports series, competing in identical cars. In one of her zanier advertising campaigns, Darlington promoted the IROC events by visually stating the obvious. Here, driver Ken Schrader opens a chest to find a rudimentary treasure map hidden inside: a rock with an eye painted on it. (Courtesy of Darlington Raceway.)

What does it feel like for a driver to enter the toughest turn in NASCAR: Darlington's turn three? These three drivers have their own way to describe it. Five-time Darlington winner Bill Elliott (right) says the turn looks about half an inch wide as one enters it, while David Green (center) shows the angle of the tight, unpredictable turn. The actions of Bobby Labonte (left) speak for themselves. (Courtesy of Darlington Raceway.)

One of the best-known and most-repeated comments about Darlington Raceway came from Kyle
Petty. Richard Petty's racing son never had much luck at Darlington, and after one particular brush
with the wall, he got so disgusted that he remarked, "They ought to fill this place up with water
and turn it into a bass pond." Despite his antipathy toward Darlington's style of racing, which he
admits he "just never got the hang of," Petty does respect Darlington. "The history of the place is
just phenomenal and you can't take that away from it," he said. The targeted fish got its revenge,
hooking Petty in this photograph from 1995. (Courtesy of Darlington Raceway.)

Fittingly, a South Carolina native, David Pearson, has posted more wins at Darlington Raceway than any other driver. A member of the NASCAR Hall of Fame, Pearson enjoyed racing on the short tracks near his hometown of Spartanburg, South Carolina, but says he never had any NASCAR aspirations. "I thought those guys must be crazy running 150 miles an hour at places like Darlington and Daytona," he said. In the end, the local fans made the decision for him, raising $1,500 to help him buy a car suitable for NASCAR. He competed in 574 races during his career and won 105—an amazing 18.3 winning percentage.

Nine
POSTCARDS
FROM NASCAR'S
MOST HISTORIC
VACATION DESTINATION

Who would have dreamed that this young boy, who began his career racing goats in 1942, would grow up to become one of the most successful race car drivers in history, topping the list of the 50 greatest drivers in NASCAR? David Pearson, the "Silver Fox," is Darlington's greatest champion, winning a record 10 NASCAR Sprint Cup Series races at the "Lady in Black." (Courtesy of Darlington Raceway.)

When she entered full-time NASCAR competition in 2012, Danica Patrick admitted she needed a lot of help and good advice. Patrick got her first-ever look at Darlington Raceway, the most notoriously difficult track on the NASCAR circuit, when she drove onto the property the day before the race. The week before, the former open-wheel star had joked that she was going to sneak onto the track in a rental car to try get a feel for the place before her first official practice session. She did, in fact, get a ride around the track in a passenger vehicle so she could check things out. Patrick made a good showing in her Darlington debut, finishing 12th in the NASCAR Nationwide Series race and 31st in the Bojangles' Southern 500. Here, Patrick gets a few Darlington pointers from Denny Hamlin, the winner of the 2010 SHOWTIME Southern 500. (Photograph by Jared C. Tilton; courtesy of Harrelson Photography Inc.)

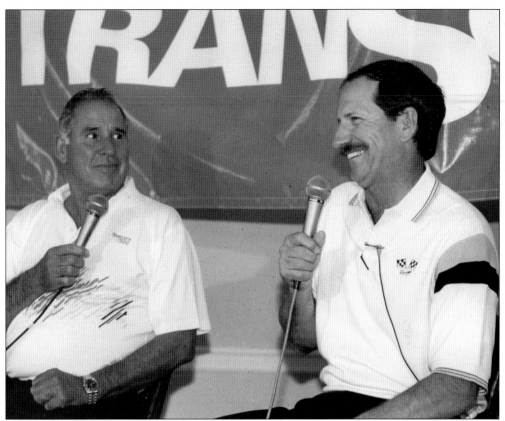

David Pearson (above left) is known as one of NASCAR's greatest talents, and Dale Earnhardt Sr. (above right) is known as one of NASCAR's greatest icons. In South Carolina, however, the pair is known as Darlington Raceway's greatest champions. Their combined NASCAR Sprint Cup Series win total at Darlington is 19, prompting some to say that, where these two are concerned, the speedway might want to change its nickname to something other than "Too Tough To Tame." Pearson and Earnhardt did a pretty good job of taming her over the years. Fittingly, both drivers were included on a Legends of Darlington commemorative ticket (below) the track issued in 2003 to celebrate the final Labor Day race weekend at Darlington Raceway. (Above, courtesy of Darlington Raceway; below, courtesy of Cathy Elliott.)

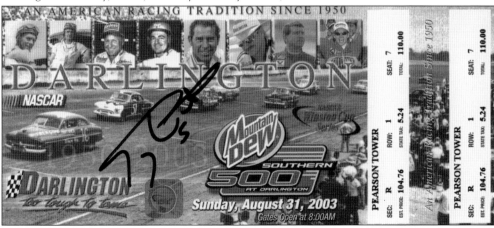

James Hylton is proof that race car drivers may age, but they never lose their competitive fire. Hylton competed in NASCAR's premier series for nearly three decades, from 1964 to 1993, and won twice, at Richmond in 1970 and at Talladega in 1972. Hylton made headlines in 2007 when, at age 72, he attempted to become the oldest driver in history to make the field for the Daytona 500. He was unsuccessful in that endeavor, and as a result, the official record book shows that James Hylton's final NASCAR race was the 1993 TranSouth 500 at Darlington Raceway, where he finished 34th. (Photograph by Hunter Thomas.)

Tony Stewart, NASCAR's champion in 2002, 2005, and 2011, looks a little pensive as he contemplates his chances at Darlington Raceway, where he has not enjoyed as much success as he has elsewhere on the Cup Series circuit. As of 2012, Stewart's only win at Darlington was a NASCAR Nationwide Series race in 2008. (Courtesy of Darlington Raceway.)

Like many drivers in the 1950s and the 1960s, Jim Reed got his racing start competing on dirt tracks and at fairgrounds, from Canada to Georgia and as far west as Ohio. The Peekskill, New York, native raced in NASCAR's premier series for 13 seasons, competing in 106 races and winning seven. The biggest win of his career came in the 1959 Southern 500 at Darlington Raceway, after finishing fourth in 1956 and 1957. The victory was his only win at Darlington and the final win of his career. Reed eventually retired from racing in 1963. He went on to own and operate a successful truck dealership in his hometown, where he celebrated his 86th birthday on February 21, 2012. He is seen here in his Southern 500–winning Chevrolet Bel Air. (Courtesy of Darlington Raceway.)

Mark Martin is one of the most popular NASCAR drivers of all time and one of the most successful at Darlington Raceway, holding the record for most support series wins in the track's long history. He took time to acknowledge Darlington's past champions while celebrating his second Southern 500 victory in 2009. "David Pearson told me I was going to go out here and win this thing. David Pearson is the coolest dude ever," he said. "We need to remember our heroes, and that's really special." Martin could well be speaking of himself, as throughout his career he has served as a mentor, a role model, and certainly a hero for many young drivers. He is known for his rigorous commitment to physical fitness and his consummate professionalism, both on and off the race track. Here, he signs a slightly-larger-than-life-size cardboard version of himself during a hospitality appearance at Darlington. (Courtesy of Darlington Raceway.)

One of the most thrilling moments of Kurt Busch's career was also one of the most disappointing, as he lost the 2003 spring race at Darlington to Ricky Craven by a mere .002 seconds. "I was just hoping, praying, that maybe we were ahead of him, but he beat me to the line," Busch (above) said. "Still, every time I tell the story, I swear I'm going to win it one day." Below, Darrell Waltrip congratulates Craven in Victory Lane after the race. Craven's car was sponsored by Tide that year, and Waltrip had driven the "Tide Ride" to nine victories in the late 1980s, including the 1989 Daytona 500. Craven's victory at Darlington was the high point of his time driving the famous car. (Both, courtesy of Darlington Raceway.)

Today, Darlington's press box and media center provide climate-controlled, modern accommodations for the use of the motorsports press corps to watch the races and write about them. Flat-screen video monitors situated around the room show both the race broadcast and NASCAR's official timing and scoring feed, indicating each driver's position at any given moment during the event. Wireless Internet access allows race coverage to be posted instantly online and transmitted to print publications. Coolers are stocked with bottled water and soft drinks, and meals are catered. In the early days of NASCAR, however, things were not so cushy. Darlington's first press box was an open-air sitting area with one hardwired telephone that was shared by the assembled writers, who had to dictate their stories in order to make the next day's newspaper. The catering options consisted of a water cooler and a picnic lunch. Despite the basic conditions, Darlington became somewhat famous for its pimiento cheese sandwiches. (Courtesy of Darlington Raceway.)

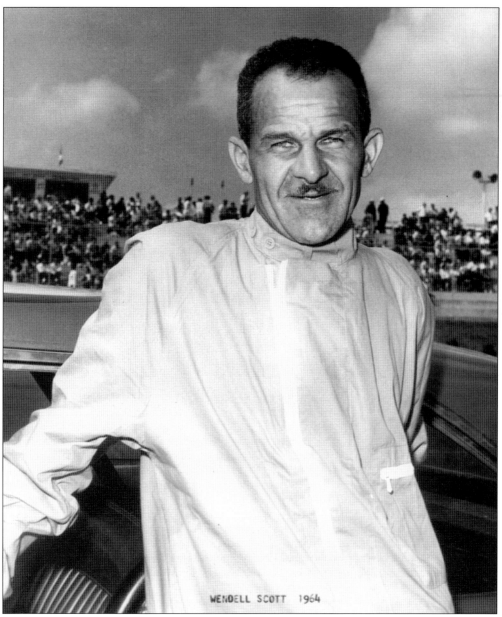

WENDELL SCOTT 1964

Wendell Scott may not be one of NASCAR's biggest names, but he is one of its most influential. For virtually his entire career, Scott was the only African American driver in racing. Like many early race car drivers, Scott started his driving career as a moonshine runner in his native Virginia, where he drove a taxi by day before trading his human cargo for the illegal liquor at night. His only win at NASCAR's top level came in Jacksonville, Florida, in 1963. However, Buck Baker celebrated in Victory Lane that day, and Scott was not declared the winner until hours after the race. In 1977, the movie *Greased Lightning*, starring Richard Pryor, told the story of Scott's career. He competed in 15 races at Darlington and his best finish was 13th, in the 1968 spring race. (Courtesy of Darlington Raceway.)

According to a study conducted by the popular sports drink Gatorade, NASCAR drivers can lose anywhere from 70 to 160 ounces of sweat during a race and can lose 10 pounds or more. Stock car racing requires an enormous amount of concentration and focus, particularly at Darlington, where the cars race so close to the wall and to each other. Dehydration can cause fatigue, poor concentration, headaches, and dizziness. Some drivers combat this by installing hydration systems that use special couplings to attach tubes to their helmets for hands-free drinking, while others just grab a water bottle during pit stops. Focus is important as well to pit crews, who must be on the top of their game when the car needs servicing. Things have certainly come a long way from the days when teams thought the best option for refueling their bodies during races was just doing it the old-fashioned way—downing an ice-cold soft drink. (Courtesy of Darlington Raceway.)

Ray Evernham is one of NASCAR's most successful crew chiefs. Working with driver Jeff Gordon, Evernham helped guide the famous No. 24 Chevrolet to 47 NASCAR Sprint Cup Series wins and three championships. The pair was wildly successful at Darlington Raceway, winning five races between 1993 and 1999, including three consecutive races and four Southern 500s. (Courtesy of Darlington Raceway.)

Below, former NASCAR champions Benny Parsons (left) and Darrell Waltrip pose for a photograph at Darlington Raceway, where they both enjoyed success. Parsons, a former taxi driver whose gentle, affable nature made him a favorite among fans and fellow competitors, won 21 races over the course of his career, including the 1975 Daytona 500. His only Darlington win was in the 1978 spring race. Waltrip was a five-time winner at Darlington, including one Mountain Dew Southern 500 in 1992. Both drivers went on to become television broadcasters when their racing careers ended. Parsons passed away in 2007. (Courtesy of Darlington Raceway.)

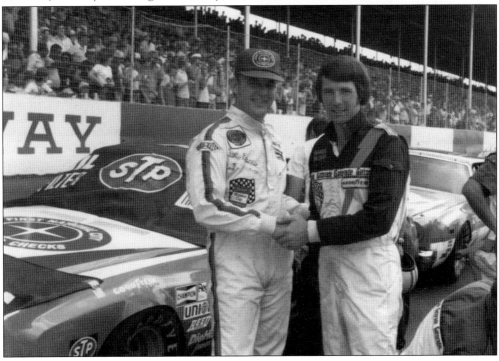

The Southern 500 at Darlington Raceway is South Carolina's largest one-day tourist attraction, attracting more than 100,000 people to the Palmetto State. Studies conducted by the University of South Carolina in 2009 estimated the annual economic impact of the race weekend at $54 million. There are many larger cities in the state, but Darlington is South Carolina's most recognizable sports name. For several years, the state's highest elected official hosted an event in honor of the track. Most of the Darlington Day activities were held on the front lawn of the governor's mansion (seen here) and included show cars and appearances from various drivers and sponsors. The flashiest Darlington Day driver entrance was provided by Tony Stewart, who once landed his helicopter on the governor's lawn. The official purpose of the day was to honor the legacy of racing in South Carolina and to support its future. (Courtesy of Darlington Raceway.)

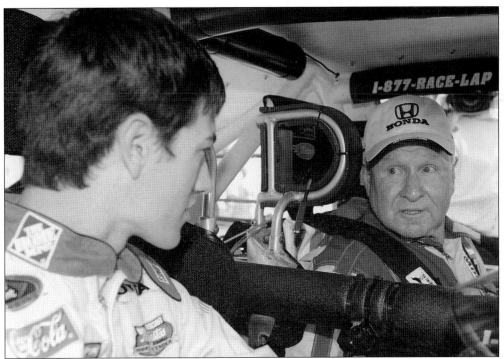

Experience is the best teacher, and two of the most experienced competitors in Darlington Raceway history are NASCAR Hall of Fame members Cale Yarborough and David Pearson. Yarborough won five Southern 500s at Darlington and admits she is his favorite track, hands down. Above, he gives a few pointers to young driver Joey Logano, who began competing in NASCAR's top series at age 18 and is the first driver born in the 1990s to win a NASCAR premier series race. Below, Carl Edwards listens intently as David Pearson, Darlington's all-time champion, shares some of his secrets to success at the "Lady in Black." (Both, courtesy of Darlington Raceway.)

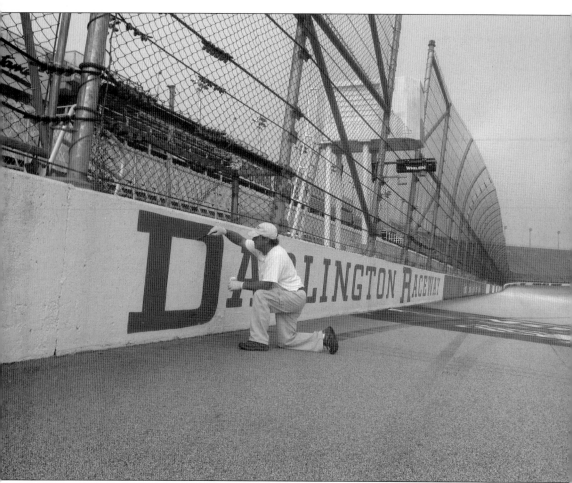

One of the most famous Darlington Raceway structures, which plays such an integral part in event outcomes that it is often referred to as "the 44th competitor," is the retaining wall. Jimmy Jolly has been leading the team that paints the wall at Darlington since 1997, often working through the night to erase the damage inflicted during every practice session, qualifying session, and race. Each repainting, which includes logos on both the wall and on the track surface itself, averages more than 100 gallons of paint and takes about six hours to complete. The fastest racing groove at Darlington is on the high side of the track, inches from the wall, which over the years has taken more drivers out of racing competition than other cars on the track have. (Photograph by Cathy Elliott.)

Darlington was designed in a different era of stock car racing, when a different style of car was used. Darlington's tight turns, irregularly shaped and much narrower than at other tracks, offer less room for side-by-side racing. Consequently, when the cars are forced to the high side of the track, it is time to say, "Hello, wall." Darlington stripes are not confined to novice drivers, although experience at the track does reduce the risk somewhat. "She'll reach out and bite you," said Dale Earnhardt Sr. Anytime a car hits the wall and slides along it, leaving a long mark, it is called a "Darlington Stripe," a somewhat ironic comparison to military stripes, which are awarded based on merit. The cars are not the only ones sporting the famous "Darlington Stripes" after races; the wall always has its fair share as well. (Photograph by John K. Harrelson; courtesy of Harrelson Photography Inc.)

A colorful story that has gradually become accepted as fact over the years centers around the roots of NASCAR. During Prohibition, moonshine runners constantly tinkered with their cars; a faster, lighter car, after all, had a better chance of outrunning the federal agents aiming to arrest them and confiscate their cargo. For fun, and for those all-important bragging rights, runners fell into the habit of holding informal races, to prove once and for all who wielded the savviest wrench. When racing evolved into an organized, sanctioned sport, participants already had a head start when it came to figuring out how to get the most speed out of their cars. The average race speed at the inaugural Southern 500 in 1950 was 75.25 miles per hour, which is fast, but slow enough to keep up with at about the speed of an average car traveling on an interstate. But mechanics have continued to find new ways to greatly increase speeds over the years. The average race speed for the 2012 Bojangles' Southern 500 was 133.802, with the cars, like the ones seen here, appearing to be little more than a blur. (Photograph by Hunter Thomas.)